PHOTOGRAPHER'S
LIGHTING
HANDBOOK

LOU JACOBS JR

Amherst Media, Inc. ■ Buffalo, NY

Published by:
Amherst Media, Inc.
P.O. Box 586
Buffalo, N.Y. 14226
Fax: 716-874-4508
www.AmherstMedia.com

Publisher: Craig Alesse
Senior Editor/Production Manager: Michelle Perkins
Assistant Editor: Barbara A. Lynch-Johnt

ISBN: 1-58428-076-X
Library of Congress Control Number: 2001134044

Printed in Korea.
10 9 8 7 6 5 4 3 2 1

TABLE OF CONTENTS

ABOUT THE AUTHOR

I'M A CAREER PHOTOGRAPHER WHO SHOOTS PICTURES TO SELL AND TO ENJOY MYSELF, AND AFTER MANY DECADES I STILL FEEL PLEASURE IN FINDING AND PHOTOGRAPHING THE SAME KINDS OF SUBJECTS YOU DO.

I've never become jaded about personal photography, and I hope I never do.

As you look at the photographs in this book, you'll find my pictures, as well as some made by friends who also enjoy shooting.

For many years I've made a living as a magazine photographer and a writer of how-to articles and books on photography. Themes of my books include lighting (I wrote about it first in 1962), darkroom techniques, single lens reflex shooting, point & shoot photography, close-ups, available light, photographic style, the business of photography and two camera manuals. I've also written and photographically illustrated more than a dozen books for children and young readers.

Over the decades I've used numerous camera brands and formats, various flash and flood-lighting equipment, many kinds of film

and a selection of tripods. I now use a late-model Canon SLR camera with half a dozen lenses, plus an up-to-date point & shoot camera that actually belongs to my wife. I am still happily motivated to take pictures for my books, to please clients and for self-expression. Photography is a creative art as satisfying as painting or composing.

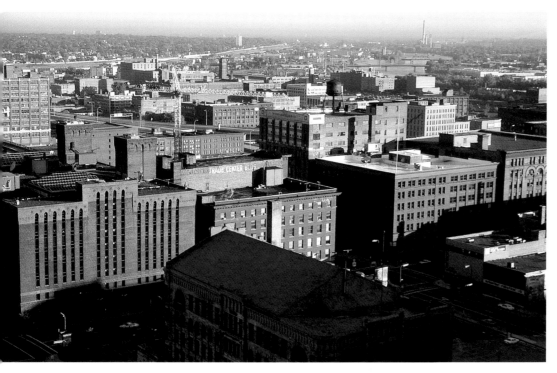

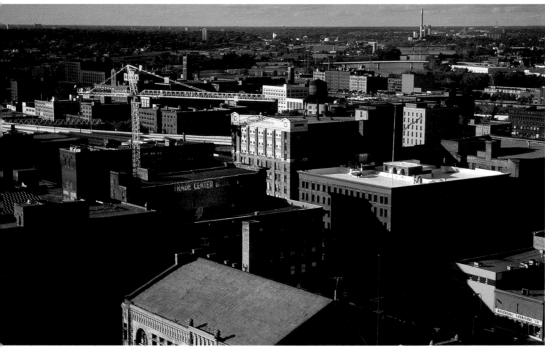

Top: Minneapolis in the morning, viewed from a hotel window. Rectangular forms stand out separately in the low sun coming from the right. Taken with an SLR and 35–70 lens on Kodachrome 64. **Bottom:** Minneapolis in late afternoon from the same hotel window. The same scene looks quite different with the sun low from the left. Recognizing and capturing lighting effects helps make strong pictures. Same camera, lens, and film as used in the morning.

INTRODUCTION

THIS BOOK HAS SEVERAL GOALS.

FIRST, I WANT TO STIMULATE YOU TO EXPERIMENT WHEN TAKING ALL SORTS OF PICTURES IN ALL KINDS OF LIGHT.

Second, I'll explain and show you how light affects whatever you shoot, from landscapes to close-ups and portraits. My third goal is to help you shoot more pictures you can brag about, more great photographs to frame.

If you think that impressive photographs depend on using lighting "tricks," you're mistaken. These tricks are reserved for studio situations, where special, often expensive equipment is used. You can shoot beautifully lit images with subtle variations in a home "studio," or even when you travel, with worthwhile techniques, not tricks. The techniques that pros use to dramatize people or things with shadows or reflectors or multiple lights are available to all of us. Our task is to learn to recognize and use good lighting. As when learning to play the piano, proficiency with photographic lighting improves with practice.

In each chapter I've presented logical facts and ideas about subjects in the clearest possible way, without fancy words. I explain terms when necessary, and include pictures that I hope will inspire you to shoot similar effects yourself. It takes time to polish your photo skills, but I'm convinced that you learn more from your mistakes than you do from your triumphs. If after really trying to light something well, or to find beautifully lit subjects, you don't mess up a lot of shots as you improve, you're not trying hard enough!

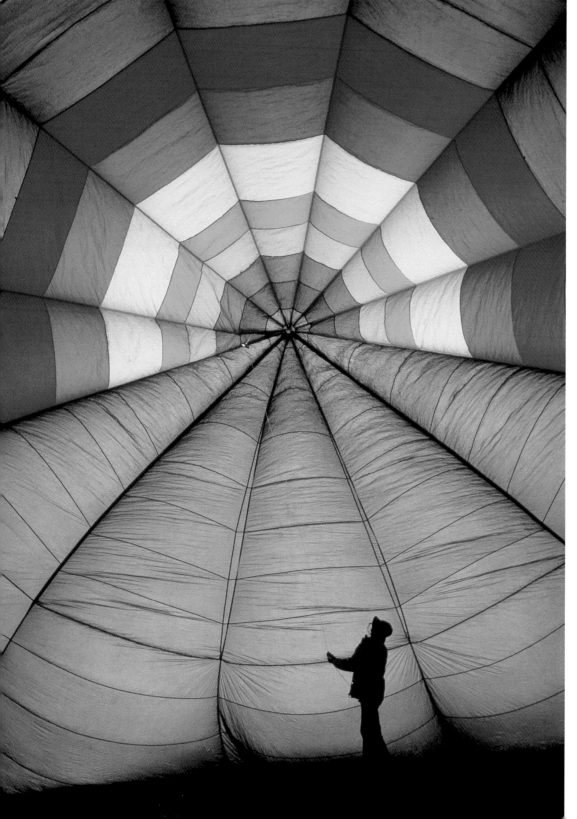

A spectacular photograph of a hot air balloon being inflated won Greg M. Taggart a prize in a past Kodak contest. The patterns in this image are backlighted, meaning light comes from behind the balloon. Dramatic photos are often backlighted. Courtesy of Eastman Kodak Co.

GETTING ACQUAINTED

WHETHER YOU FEEL LIKE A COMPETENT PHOTOGRAPHER OR NOT, I HOPE YOU ENJOY TAKING PICTURES OF PEOPLE, PLACES AND THINGS.

Experienced or not with lighting, I also hope you want to understand more about using light as a marvelous photographic tool. Appealing, beautiful, eye-catching pictures with real visual impact—those that win contests or become magazine covers—depend on admirable lighting effects. Whether you plan to take pictures in nature's light or with the man-made kind, the photographic considerations listed below will help you to build a foundation for stunning images of special places and important moments.

PICTORIAL INGREDIENTS

Subjects. Children, lovely landscapes, pretty girls and handsome men, dynamic action—these are a few of a long list of subjects that grab peoples' attention and stir their emotions. Fairly ordinary subjects can be winners

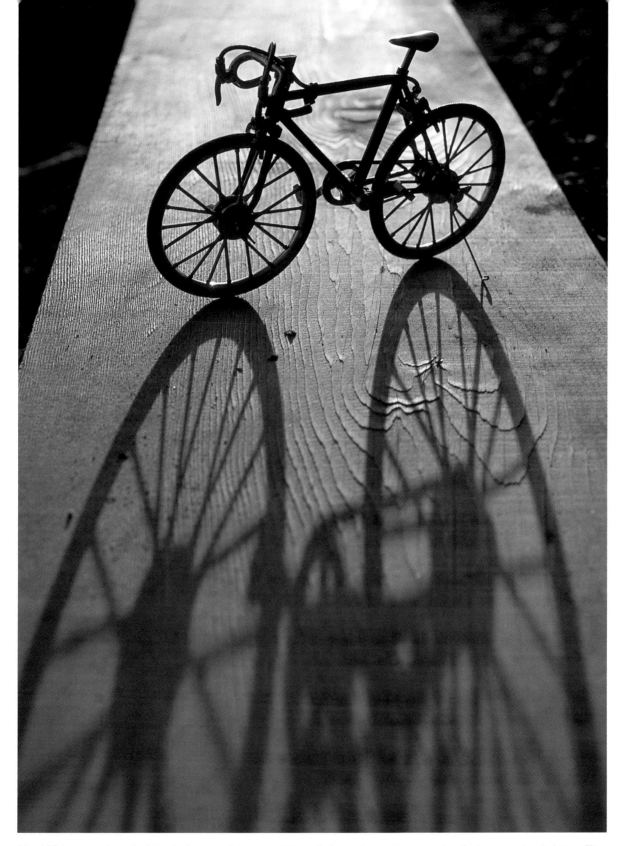

Ken Whitmore placed a bike in low sunlight on a sidewalk for a dramatic example of photographic lighting. The picture was made as a decorative highlight for an annual report using a Nikon 35mm SLR on a tripod, a 24mm lens and color slide film. It's a fine example of back lighting with a dominant shadow.

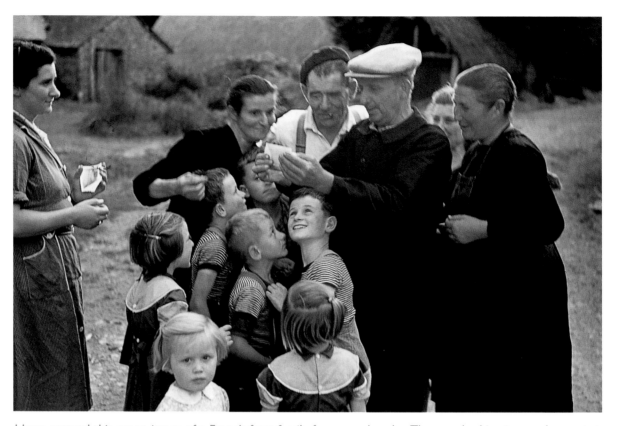

I have savored this group image of a French farm family for many decades. They are looking in wonderment at themselves in their first experience with a Polaroid print. In the mid-1950s instant photography was rare in Europe, and they posed for me, not realizing what was in store. Thin clouds filtered the sun to create beautiful light. I used a rangefinder Nikon SP with a 35mm lens and Kodachrome film.

when photographed in excellent pictorial conditions.

Stories. Not all pictures have a story to tell, but when people talk, cry, shout or passively enjoy life, try to catch their emotions in photos. Leisure interests become picture stories or narratives when you capture moments that affect viewers.

Composition. *Composition* defines the way we see and organize images. It's based on basic design principles found in books, magazine articles, classes and seminars or at camera club debates. What makes a good composition is somewhat controversial, but that's okay, because enthusiastic discussions about improv-

ing photo composition are, and should be, challenging.

Strong compositions attract viewers' interest through use of a dominant subject (the largest, most colorful or closest object to the camera). Other (secondary) subjects in the picture give visual support to the dominant subject. Remember that beautiful, dramatic, successful composition and, therefore, great pictures, are also dependent upon the beauty and drama of lighting.

Color. It's usually a personal topic. I assume that reds, yellows, greens, blues, rust-orange and mixtures of those hues appeal to everyone. Nature manufactures great color

combinations outdoors that we photograph in pastoral landscapes, mountains, deserts, fields, green trees, yellow flowers, deep blue oceans and skies. People also dress and decorate colorfully. When shooting still lifes, portraits, children or backgrounds, you usually have some control over the colors involved.

Contrast. The term *contrast* is used here to refer to more than just light and dark tones. Complementary colors, varying subject sizes, illusions of perspective, active and passive subjects and opposing facial expressions create considerable contrast, too. As a student, I was advised to arrange dark tones against light ones, and vice versa—an excellent approach to giving your pictures pizzazz. An image of a white horse in a group of tan or black horses, a bright face against a shadowed drape or brilliant flowers against dark leaves will draw the viewer's interest.

Drama and Excitement. A photograph of a crying baby, a startled expression or a leaping ballplayer can arrest an observer's attention—even if your camera angle isn't perfect. Humorous situations are also visually magnetic.

Lighting. The quality and direction of light directly influences the appearance of every subject in every image. No matter what your preference for light sources, lovely lighting can excite you to produce first-rate photography.

The direction of the light and what it shows or hides in shadows stimulates the viewers of our prints and slides. With good lighting, an image can snap to life. A subject that seems to lack character, treated with effective lighting, can be transformed into an attractive image.

LIGHTING TO SUIT THE SUBJECT

Modulated Light. Outdoor light changes with the weather, the season and the time of day. Picture-worthy daylight may be cloudy, foggy, sunny or filtered through thin clouds. The warm color that results from early morning and late afternoon sun is a big favorite of photographers. Of course, photographers should also consider shooting in the rain, as the light is usually soft and shadowless. Cloudy days without strong shadows are detrimental to landscape photography, but the quality of light produced is very appealing for portraits. Soft, indirect light coming through a window can be positively pictorial, even glamorous. Looking for photogenic light or trying to create it is a never-ending obsession for photographers.

My nephew, Jim Jacobs, is a professional geologist with a talent for photography, which shows you don't have to be a photo pro to make images with impact. Late afternoon sun in Houston created dramatic contrast for a fine composition. Jim used an SLR, a 105mm lens and Kodachrome, and the camera was braced on a window ledge.

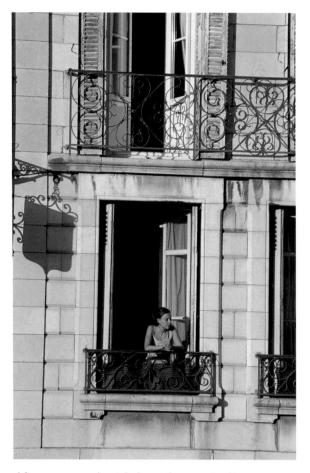

Afternoon sun (again) does photogenic things to various subjects, such as this lady on a balcony in Bayonne, France. I was exploring for pictures and found her with a Canon 75–300 IS (image stabilization) lens that I could handhold steadily at $1/125$ second with 100 VS Ektachrome.

Modulated light might be called ideal lighting. It is the type of lighting employed in movies, TV, advertising and editorial portraits—in short, wherever professional photographers use their equipment, studios and experience to achieve top-notch, controlled illumination.

On many movie sets, shooting magazine stories, I've watched cinematographers direct lighting assistants to shift, add, turn off or diffuse huge floodlights attached to multiple beams above a sound stage. Fifty years ago, the process aimed to achieve a more formal or conventional lighting. In recent years, however, lighting styles used in movies and TV have become more subtle, more shadowed and increasingly daring. Modern lighting techniques have been tailored to suit the very *moods* of stories or documentaries.

Look closely at the way indoor scenes are lit in movies and television. Be aware that entire rooms may be evenly lit, though you may not be aware of where the light comes from. Notice whether shadows are brightened (filled) or allowed to remain dark. Note that dramas and mysteries often use contrasty lighting to accentuate mood; when the plot turns ominous, dark shadows are used to amplify suspense. Examine, too, the way people are lit: close-ups of actors are lit to suit a particular place or plot. Good guys are usually more pleasantly lit than bad guys, who are lit to appear threatening. Comedies and less serious stories are comparatively brightly lit, often with few shadows.

Advertising photographers' studios are smaller than movie sound stages, and electronic flash is almost always used to cover medium and small areas (cinematographers need lots of multi-watt incandescent equipment to cover big movie sets). When professionals work in rooms or offices, they may use big floods and spotlights. Lenses may be filtered to match existing ceiling fluorescents and accent lights. Architectural photographers are experts at adding illumination to augment existing light. Look at Frank Peele's library interior in chapter 7.

For more examples of good lighting techniques, study the portraits found in magazines. I've been clipping samples from various national magazines, newspapers (as well as their Sunday magazine inserts) and other sources since I began work on this book. These portraits serve as reminders of sophisticated or simple techniques worth studying. Lighting in magazine illustrations usually appears fairly even. Clip photos you admire, and you'll get a feeling for lighting effects you might want to try.

You can bring much of the learning garnered from observing television, movies, advertisements and editorial images to your own photography, adapting the lighting styles used to the number of subjects you plan to photograph and the size of the space in which you'll be shooting. As with all artistic analyses, you'll likely encounter work that does not appeal to you—in fact, you may even find work that is not well lit. Of course, this can be instructive, too.

SELECTING CAMERAS AND LENSES

By now, you may have wondered if you have enough photo equipment, or are using the "right" kind of camera, flash or other light source. You should realize there's no one right camera for everyone. A camera you feel comfortable with—one that produces satisfying images, offers enough exposure modes and minimum frustration, no matter the make or model—is right for you. The same can be said for a flash unit or quartz light. It is a good idea to consider using both a single lens reflex camera and a point & shoot camera, as each type has its advantages in specific situations.

Point & Shoot Cameras. Also called compact cameras, these are favored by many people because they are convenient, versatile, lightweight and usually affordable. Point & shoot cameras automatically set exposure and focus, and can determine when flash is needed so you can concentrate on finding and composing pictures. From the many point & shoot cameras on the market, choose one with a useful zoom lens range such as 38–105mm or 38–135mm. Read the instruction booklet and become familiar with your camera's features to maximize your picture-taking possibilities.

Benefits of point & shoot cameras:

- They are easy to carry and they make most technical decisions for you.
- Because many point & shoot cameras are so compact, opportunities to be creative in many kinds of situations are possible despite certain camera limitations.
- Their lenses are often excellent, and with a variety of shutter speeds, the cameras perform well in many lighting situations.
- Point & shoot cameras are well suited to using negative (print) films, which include a wide exposure latitude.

Important controls not found in point & shoot cameras:

- You are limited to the lens built into the camera.
- You can't see what's in focus

through the finder, and close-up shooting is limited.

- You can't choose specific shutter speeds or lens openings, but the camera usually does it very well.
- Many point & shoot models lack shutter speeds slower than one second or faster than $\frac{1}{400}$ second. The fastest speed is okay for most action, though the one-second limitation may yield poor results in dim light.

- Special effects modes, such as intentional multiple exposures or exposure compensation for bracketing, are not available in many point & shoot models.

Single Lens Reflex (SLR) Cameras. When shopping for an SLR, photographers will find that there are dozens of models available from numerous manufacturers on the market. In the early 1980s, when I switched to an auto-focus camera, I made a chart of fea-

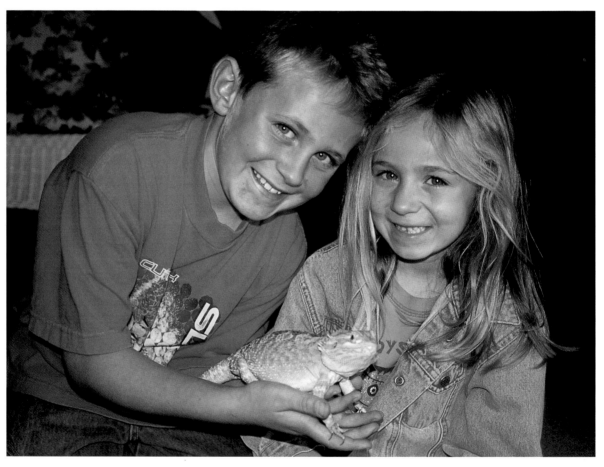

Children are probably the number one subject of point & shoot camera users. Turn on the camera, extend the zoom lens if necessary, and frame the subject in the finder. The camera sets the exposure and focus, the flash comes on in low light levels, and you can concentrate on activity and facial expressions. If the children won't pose, follow them and shoot when you like what you see. These children posed with their pet bearded dragon from Australia.

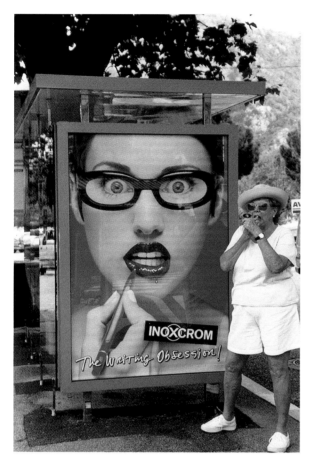

Murray Olderman snapped his wife Nancy next to a related poster in southern France. He noticed the gentle satire, which seems consistent for a sports cartoonist. The light was lovely on a partially overcast day, as you can tell by the lack of shadows. Murray used Fuji 200 print film in a Canon Rebel SLR, and later scanned a 5x7 commercially-made enlargement into his computer, and printed an 8x10 for me. Humor in photography is welcome in any light.

tures I wanted, then gathered brochures from Canon, Nikon and Minolta. My comparisons indicated I would like working with a Canon SLR. I didn't buy the most expensive, complex model with features I didn't need, and I've been quite satisfied with the Elan, and now the Canon A2 as well. Make your own

chart of camera brands, features and models, to compare SLRs with point & shoot cameras. Consider camera weight and how a camera feels in your hands at a photo supply shop, and compare prices, too. You might also consider requesting catalogs from some of the sources listed at the end of this book.

The advantages of using an SLR:

- Through the finder you see what the lens sees, such as focus changes and depth of field, which shows you the closest and farthest subjects in focus at a distance and lens opening you choose.
- Shooting close-ups with various lenses and setting precise compositions are a pleasure.
- You can manually or automatically vary exposures to suit subject brightness. This is a very useful option when shooting color slides, which need precise exposure.
- You can shoot special effects, such as zooming the lens during exposure.
- You can shoot a fast sequence of pictures, perhaps three or more per second.
- You can bracket your exposures with automatic or manual exposure adjustments. This means that you can shoot a series of images that are varied by a small change in shutter speed and/or aperture to ensure that the best possible exposure is achieved.
- Most SLRs offer a large range of shutter speeds—from thirty seconds to $\frac{1}{1000}$ second (or faster). Other adjustments

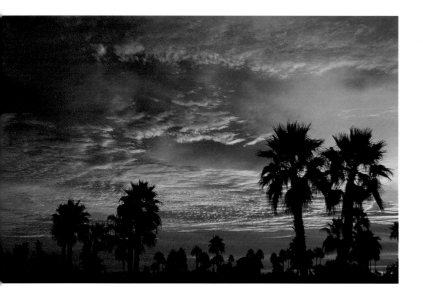
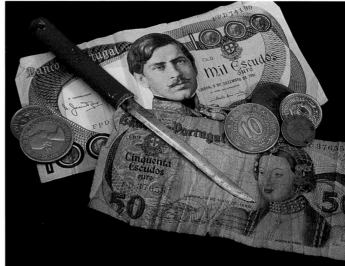

Left: Sunrises like this, and sunsets, are among the most popular subjects entered into photo contests, which suggests that you must shoot a really outstanding sunrise or sunset to be chosen a winner. I took this with a Canon Elan and Canon 28–135mm lens on Ektachrome 100VS while standing on the roof of my home. **Right:** When the weather outside is nasty, stay indoors and set up still-life compositions for the fun and challenge. Choose similar or incongruous subjects, as I did with Portuguese money and an old letter opener on a black cloth background. A 500-watt reflector floodlight was reflected from an umbrella, and I used an 80A filter to cool the light to match Ektachrome 100WS film. There was a Sigma 50mm macro lens on my SLR.

such as exposure compensation, depth of field preview and selective focus are often included as creative controls.

- A wide variety of lenses are available for SLR cameras. Auto-focus zooms and single focal-length lenses ranging from very wide angle (15mm) to telephoto (500mm) provide photographers with a great deal of creative control. Changing lenses to meet various photo opportunities is a strong SLR advantage, and many SLR lenses are sharper than those in point & shoot cameras.
- Many accessories such as filters, flash units and lens extenders (which increase the lens' focal length) are available for use with SLR cameras.
- With the many options available—from accessories to built-in creative controls—photographers can successfully shoot a wide variety of subjects and lighting conditions.

Disadvantages of SLR cameras:

- They are heavier and often bulkier than point & shoot cameras.
- Cameras and lenses are generally more expensive than point & shoot cameras.
- They are often complex and you will need to become familiar with more modes and settings.

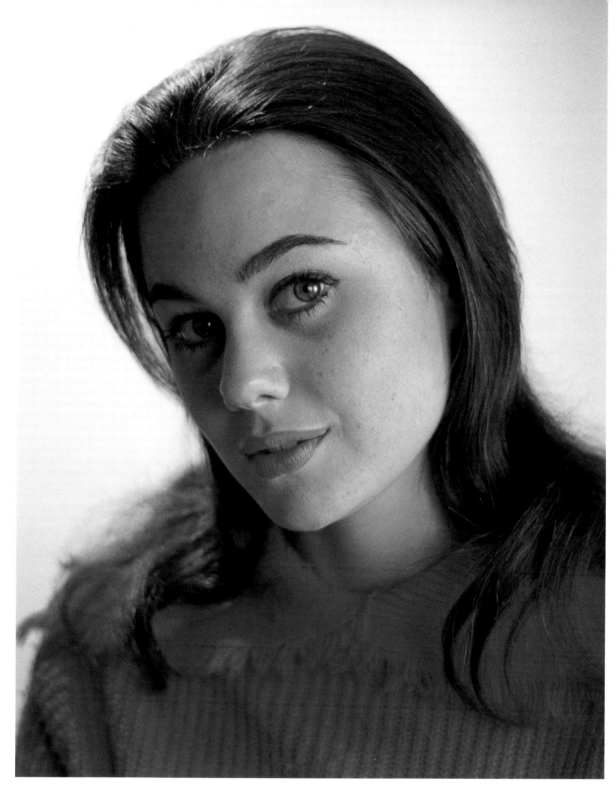

In the 1960s a publicist friend at a movie studio offered me a new young actress as a model, and brought her to my improvised living-room studio where I hung background paper. I reflected the main flash, a portable Vivitar 283, into a white umbrella at the right, and set a smaller flash with a slave eye on the background. On my SLR loaded with Kodachrome was a 28–105 lens. We shot a 36-exposure roll, changing poses and camera angles, and talking. I'm sorry I don't remember the subjects that we discussed.

Digital Cameras. Most digital models, like point & shoot cameras, use a non-removable zoom lens. There are dozens of digital models on the market, and the prices are dropping. A few of the more expensive models are SLR cameras, which can accept an array of SLR lenses.

Before shooting with a digital camera, you see a bright image on a small screen finder on the back of the camera, and also through a window finder with most models. Immediately after making an exposure, you view what you shot on the mini-screen. If you don't like the picture you can delete it and take a better shot on the disk where images are stored. There are no expenses for film and processing. Disks from the camera can be placed in your computer or in a printer, and you may fix flaws with the help of photo-editing software. You can then print the best images, post them on a web site and/or send them to friends and family via e-mail.

In most cases, the more expensive cameras offer a higher pixel rating than lower-priced digital cameras. A higher pixel rating will allow you to make larger sharp prints. As of this writing, digital models costing $500–$700 are quite versatile, and for about $900 you can buy a camera suitable for professional-quality work.

Digital or Conventional? The type of camera you ultimately select should be well suited to your photographic needs. If seeing your shots instantly, obtaining digital images without scanning and never having to worry about running out of film are top priorities for you, digital could be a blessing. On the other hand, if you want slides, or like the conven-ience of commercial film and print processing and aren't interested in honing your computer skills, a point & shoot and/or conventional SLR seem(s) a better choice.

Final Words. With some basic experience, conventional negatives, prints and slides can be scanned into a computer and digitized. No matter what type of camera you use, an understanding of lighting is vital to shooting satisfying and appealing photographs. When you recognize wonderful light and have an engaging subject, the camera—whatever the type—is a tool used to capture the pictorial quality you're after.

WHAT'S NEXT?

Now that you've selected the camera type best-suited to your needs, and understand what subjects, themes, etc., make for a good image, it is time to turn your attention to lighting.

To increase your awareness of what constitutes good photographic light, begin testing your perceptions of lighting effects indoors and out. In other words, go out and shoot some pictures! Pose someone by a window, photograph a local soccer game, walk in the woods or in town and become a visual explorer. Worthy subjects and opportunities can be found almost anywhere. Develop your sensitivity to find them. Many times we see something that would definitely have made a good picture and are too lazy or too hurried to shoot. Keep a camera handy. Look for pleasing subjects and experiment. Devise photo exercises for yourself, and get excited. Do a picture series of your pet or child. Whatever your subject, devote enough time to the task of discovering how it is best lit.

Ready or Not. If you're not quite ready for photographic exploration, delve into the chapters of this book that most appeal to and intrigue you. The lighting exercises in chapter 3 might lead to great discoveries. In addition, examine the photographs you've taken. Pick the best and write yourself notes about the lighting. How could you improve the pictures? What kind of subjects do you want to shoot? The pictures in this book will give you ideas.

As you read through this book, gather additional inspiration by reading a photographic magazine like *Popular Photography*. Study the pictures and how they were taken. Analyze photographs in *National Geographic* magazine or any familiar magazine with quality images. As your enthusiasm grows, it will become easier to analyze lighting and do whatever is necessary to prepare for your own photographic adventures in lighting.

PHOTO PROJECT

To begin, try to create a photo that illustrates one or more of these topics:

- Composition
- Color
- Contrasts
- Action
- Patterns

Find subjects that illustrate the topic that most interests you. Shoot outdoors in sunlight, bright shade or in any artificial light that suits the subject. It's okay to combine several categories for your pictures, but one may dominate. For example, pictures of children swimming or playing would involve composition, color, lighting and action. Look for peak action, which means snapping the photo when action is at its best, such as a child in midair. In any category, try to choose a time and vantage point when light and camera angle show your subject well. Study your best shots and determine how they could be improved.

EXPOSURE EXPLAINED

SINCE ALMOST EVERY 35MM CAMERA MADE IN THE LAST TWENTY YEARS HAS AN AUTO-MATIC EXPOSURE CAPABILITY, YOU MAY WONDER WHY YOU NEED TO UNDERSTAND HOW AUTO EXPOSURE WORKS.

The reason is this: If you've had over- or underexposed negatives or slides, and you knew there was enough light, you'd probably like to know why your auto-exposure camera failed you. The answer lies in your camera's auto-exposure system. Basically, flawed exposures occur because the light falling on the subject or scene was excessively contrasty, or the subject had mostly light or dark tones without much contrast. A meter is designed to average the light, so an excess of bright or dark tones can make an average exposure erroneous. Disappointing exposures may also occur when your camera's shutter speeds are not slow enough to capture an image in dim light, or when the subject is too far from a flash to be effectively illuminated. We'll discuss the ways in which poor exposure and contrast can be handled in this chapter.

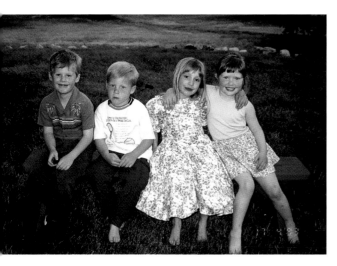

Above: In the shade, this picture might have been relatively dull because of too little contrast between the children. Using the in-camera flash of a Canon Z-135 point & shoot, I brightened the kids and boosted contrast, and the exposure was automatic. Flash fill enhances many photo situations.

CAN CAMERA AUTO-EXPOSURE METERS BE TRUSTED?

Yes, with one condition: when you photograph a beautifully lit scene or portrait, you must know how the in-camera meter "sees" the light.

A metering system converts lighting on a subject into an f-stop–shutter speed combination, and in a vast majority of cases, the resulting exposure is right on. Sensors within the camera accurately measure light coming through the lens, and electronic components do the rest. However, differences in the subject's tonality may influence the accuracy of exposure averaging.

Electronic exposure systems are amazing. Experience shows that a point & shoot or SLR camera meter does an excellent job of measuring light and setting correct exposures, a small miracle we take for granted. Color negative

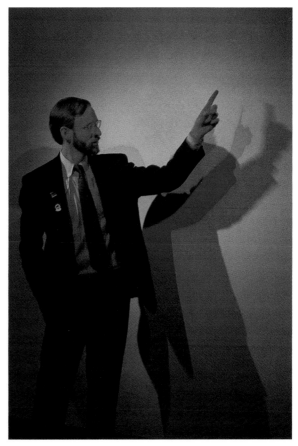

Above: At a technical lecture I covered for a magazine, the speaker arranged three small spotlights, red, blue and yellow, to explain how colored light overlaps to make green, orange and magenta. I found the demonstration fascinating, and remember exposing the picture with the in-camera meter on Kodachrome 200. You could try colored gels over flash or floodlights for a similar experiment.

films have valuable *latitude,* which means these films can be overexposed two stops or underexposed about one stop and still produce suitable negatives to make acceptable prints. Related fact: Color slide films have relatively little latitude, so over- or underexposure should be avoided. Film latitude is important to point & shoot camera users especially, because you are probably not able to

manually adjust for over- or underexposure. When necessary, SLR owners can manually override the exposure automatically set by the meter. After all, human judgment supersedes electronic performance.

Many modern SLR metering systems make their readings off the film plane rather than via a sensor in the path of the image. Exposure systems calculate light intensity milliseconds before the image reaches the film, and set exposure accordingly. Whether off the film plane or via sensors, I am awed by this capability—and the phenomenal speed with which it occurs. We are all indebted to the technical experts that have made it easier to produce the superb exposures we enjoy. Camera exposure systems work beautifully, and I refuse to admit how long it took me, many years ago, to thoroughly understand the relationship between averaging and exposure adjustment. This chapter will guide you in realizing when exposure compensations are advisable.

18 PERCENT GRAY

Imagine a scene with bright reflections on a swimming pool, gray concrete sidewalks, green grass, a tall brown wooden fence and a nice blue sky. Areas of bright, medium gray and dark tones in this imaginary sunlit scene should result in good camera exposures because there is an array of tones that an exposure meter magically averages into 18 percent

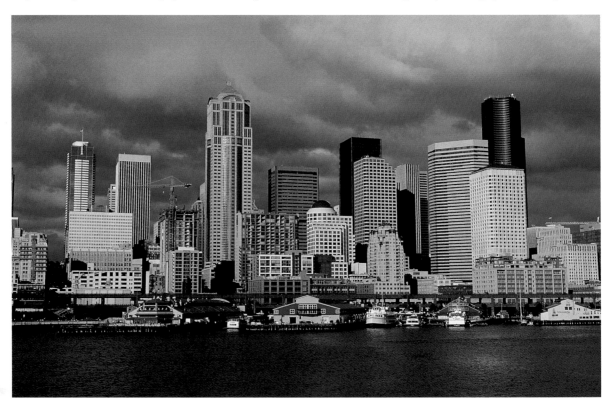

Afternoon sun filtered through clouds to highlight the Seattle skyline, behind which were more clouds threatening rain. I shot from a Puget Sound ferry, and my Canon Elan II chose the correct lens opening to match the $1/180$ second shutter speed I set. Limited contrast adds up to a normal 18 percent gray exposure.

gray. To put it another way, the meter combines the intensities of bright, medium gray and dark tones into 18 percent medium gray to produce, in most cases, a quite acceptable exposure. Meters mix light intensities as a painter mixes black & white pigments to produce gray.

To see what an 18 percent gray looks like, buy a gray card in a photo supply store. A standard photographic gray card is the middle shade in the photographic gray scale. Before camera shutters were electronically accurate, photographers often pointed a camera or handheld meter at an 18 percent gray card to determine exposure. To try this today with a point & shoot camera would mean holding the shutter release down to retain a gray-card exposure for a subject you're shooting. That can be clumsy, slow and unnecessary in a majority of lighting situations. If you are using an SLR, you'll only find a gray-card reading valuable in high- or low-contrast situations, as outlined below. Once this reading is obtained, you can make the adjustments described in the next section.

OVER- AND UNDEREXPOSURE

As mentioned, negative films offer leeway for less-than-ideal exposures to be printed nicely—especially overexposures. Slide films have almost no latitude for exposure errors. Color in overexposed slides goes pale, described as washed out, while underexposure darkens bright colors and renders shadows with minimal detail.

If your camera meter is operating properly, film characteristics help explain why some exposures aren't right on. The basic reason?

What you photograph doesn't always reflect the light in suitable amounts of bright, medium and dark tones, so when some scenes are compacted into 18 percent gray they may result in over- or underexposure.

Overexposure. You are photographing a group of people in shade. Most of them are wearing dark colors and the background is a dark porch. The camera meter averages the tones and determines that the scene has to be brightened to 18 percent gray, so a larger lens opening or slower shutter speed is set. The result is an overexposed negative (harder to see and print through), though in most cases it can be printed. Overexposure is the enemy of slides, causing a loss of color saturation and washing strong colors out to pastels.

Making Adjustments. With any exposure-adjustable camera, exposure for a predominantly dark scene should be decreased about one stop. That means if the meter reading indicates f/8, you set f/11 instead. Years ago that seemed crazy to me. Shouldn't a dark scene get more exposure, not less? Not so. In averaging, the meter elects to convert dark tones to 18 percent or middle gray, which causes overexposure. Put this statement to the test yourself. Set up or find a predominantly dark scene, and expose it at the camera-meter setting, then at one stop less. You may not see much difference in prints from negatives, but slides may be too light at f/8, and at f/11 they're okay. Experiment with varying exposure increments for dark-dominated scenes.

Underexposure. Imagine a scene with a bright yellow home or barn, some bare trees, white clouds, and snow on the land and build-

Imagine the pale orange and red leaves as bright silver, and the background black, as it almost is. The silver leaves would have registered less than normal exposure, which could have resulted in a dark slide. For one frame I added half a stop more exposure as compensation, but I also shot at the in-camera meter f-stop and shutter speed. The resulting photograph was this one, an image of autumn leaves in Alabama.

ing. A meter averages the dominant bright tones and comes up with an f/16 exposure. But when you hold a gray card in the sun, the meter indicates an exposure of f/11. (These are hypothetical lens settings.) Shoot the snow scene at f/16 and the snow will be gray with an underexposed building as well. Shoot the snow scene at f/11, f/8 or between the two settings, and the snow should be white with shadow area accents. Neophytes see all that snow and the bright house or barn and believe the f/16 setting is just fine—and maybe it will be with a non-adjustable point & shoot camera. Being able to compensate for brightness-dominated subjects with an SLR can be helpful for negatives and imperative for slides.

Summary. A scene that is predominantly bright needs to be overexposed about one stop. A scene that is predominantly dark-toned needs to be underexposed about one stop. Please make your own comparison pictures in various lighting conditions to better understand how your meter averages light.

HANDHELD METERS
Many professional and fine-art photographers use handheld meters in the studio and on loca-

Right: It was raining when I visited the wonderful Guggenheim Museum in Bilbao, Spain, and the sky stayed cloudy when the rain stopped. Behind the museum is a shallow man-made stream that unexpectedly steamed because of the temperature change. It didn't occur to me that the scene would require exposure changes from normal since it was already medium shades of gray. Ektachrome 100VS in a Canon Elan II with 28–135mm lens.

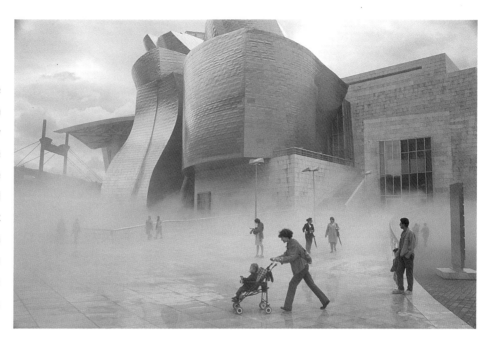

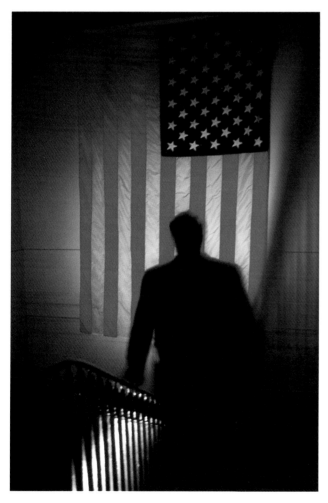

Left: Luckily, the camera meter saw this scene of a man descending a staircase as 18 percent gray, because I had no time to analyze, and in seconds I grabbed two shots at $1/30$ second. I'm often surprised how many lighting situations are well exposed without altering the camera meter's setting. Flash fill would have ruined the mood. The film was Kodachrome 200.

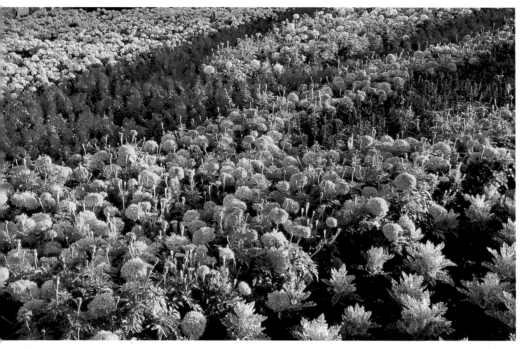

Left: At the International Peace Garden, exposure was no problem. I just used the meter reading, and any color film could have been used. The challenge was choosing a composition to capture a rainbow of flowers in every direction. Half of the garden is in North Dakota and half in Manitoba, Canada. Near the end of the afternoon the slanting sun was perfect to highlight the flower rows. I used a 28–105mm Canon zoom on a Canon Elan camera loaded with Ektachrome SW.

tion, especially with larger-format cameras that have no internal meters. Relatively expensive handheld meters read reflected light, as does a built-in meter, but they also measure incident light, which is the light falling on the subject. Incident metering is favored by some commercial and fine-art photographers, for shooting transparencies. However, exposure compensation may also be needed with incident light metering of dominant bright or dark subjects. Incident vs. reflected metering is subject to much debate. Both types of metering average the light, but those of us with

Right: A still life such as this one by Kathy Jacobs, my wife, may be taken in sunlight, shade, or indoors with artificial light. In each case the type of light could be corrected with a filter. Indoors with flash, no filter is necessary with color negative film, and an 82A or 82B would work with hot lights. This was shot outdoors with a Canon Z-135 camera in hazy sunlight using a 1A skylight filter. The background was black cloth.

in-camera reflected-light meters have few complaints, especially if we modify exposures to suit scene contrast.

Handheld meters for *flash* exposure also measure existing light, and are very versatile. I'll discuss them in detail later.

FILM CHARACTERISTICS

Comparable film types and speeds by Kodak, Fuji or Agfa are often interchangeable and easiest to find. Film with names that end in "-color," like Fujicolor, are negative or print films, while names ending in "-chrome," such as Ektachrome, are slide films. I have little experience with today's Agfa films but pictorial examples I've seen in magazines show excellent greens and warm colors. All the Kodak and Fuji negative films I've used have been quite satisfactory. ISO speeds 100 and 200 in negative films are favored by many photographers and offer fine color. ISO 400 films give you an advantage when shooting in dim light or with flash, and modern ISO 400 films also offer excellent color. Slide films rated at ISO 100 and 200 are also popular and have fine grain. Fuji Velvia colors are vivid and popular. It is rated at ISO 50 but should be exposed at ISO 40, which is often too slow when I handhold my SLR. Matching film speeds to light sources will be covered in chapters 5, 7 and 8.

Color Negative Films. A majority of photographers use color negative films, including newspaper photographers because either black & white or color prints can be made. Commercial negative processing and printing operations are fast and can do an excellent job of adjusting color for good print quality, though underexposed negatives may produce muddy prints you can easily hate. Take comfort that billions of inexpensive, excellent color prints are made yearly from all kinds of cameras, simple and complex.

Slide Films. Many professionals and other serious photographers, especially those selling to publications, use transparency or slide films because many clients prefer them. Slides are *first generation*. That means that the images captured on film passed through the camera, and are originals, so colors tend to be quite authentic. Prints made from negatives are *second generation*, meaning the negatives were interpreted by very sophisticated printing machines run by technicians who may or not be experts. Color prints are subject to variations the photographer didn't intend—another reason why color slides are favored by book and calendar publishers.

Excellent prints are routinely made from slides, though they cost more than prints from negatives. Custom color-printing methods are so good that many photographers, including professionals, offer prints from both slides and negatives for presentations and reproduction. In addition, digital prints can be sharp and exhibit accurate color. Professionals don't hesitate to deliver these prints to fussy clients.

Digital prints are made from digital cameras, or from scanned slides and negatives, and may be deftly improved with a computer program like Adobe® Photoshop®. If you make prints at home from scanned images, or directly from digital camera disks, you know the fine quality possible from desktop printers on good photo-quality paper.

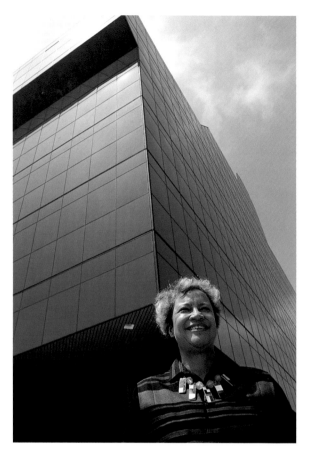

Left: I posed architect Norma Sklarek in front of a huge blue building she designed in West Hollywood, CA, for a magazine story about her. The meter in my Konica T-4 SLR selected the exposure on Kodachrome 64, and I elected to underexpose half a stop to be sure none of the bright tones washed out. I also shot at the camera-selected exposure, which lightened the building too much. Underexposed by a full stop, it was too dark.

Right: A kids' soccer game is always an appealing subject, even on an overcast day like this, when Charles Rogers made this dynamic image. It's the kind of situation that requires luck and a sense of good timing to anticipate the action—and there will be many near-miss shots. The picture won a prize in a Kodak contest some years ago. I can only guess it was taken with 200 or 400 speed negative film in a 35mm camera. Courtesy of Eastman Kodak Company.

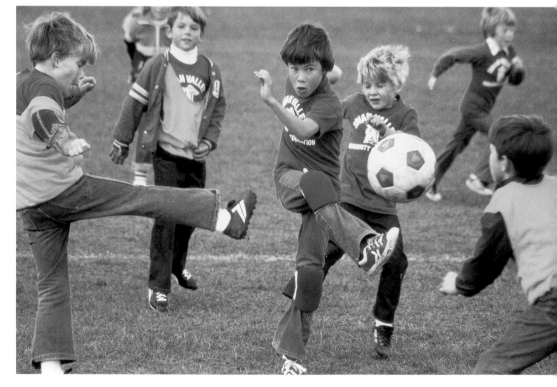

WRAP-UP

With whatever film and cameras you use, be aware of exposure extremes in predominately bright or dark scenes, and bracket (vary exposures) if you can. For experience, set up high and low-contrast situations indoors or out as described in the photo project at the end of this chapter. These are exercises, so don't worry about making great pictorial images.

PHOTO PROJECT

Find or set up a high-contrast subject, such as people in light-colored clothes in bright sun, or a dark subject with a rather dark background. Use directional sun, flash or hot lights indoors. Side lighting helps create contrast. Photographing subjects in extreme contrast and minimal contrast will help you understand the camera's metering system.

When you use flash to brighten shadows, it should be evident in slides or prints. Test shots made with and without flash fill can be educational.

Shoot a scene with both bright and dark areas, and find out how they averaged into 18 percent gray. Using an SLR camera, shoot varying contrast situations at meter-indicated exposure, then one stop over and one stop under. Evaluate detail you see in the bright areas and in shadows. Keep exposure notes.

Try these exercises on an overcast day to see how lower contrast is handled by the camera meter. To learn more, ask a friend to shoot the same situations you do with a different film, and compare results. Types of film and different film speeds may make pictorial differences.

OBSERVATIONS

- Lux is the Latin word for light, referring to sunlight, which in the B.C. era became a natural and perpetual source of inspiration for artists. The attraction of lux outdoors is responsible for more memorable photographs than all other light sources.

- Many pictures are taken because the subject is appealing, but unfortunately the photography is flawed, though not the exposures. Many pictures are taken because the light is beautiful or dramatic, but the subject is mundane.

- One reason to carry a handheld meter (even when you trust your in-camera meter) is for spot metering, which means to measure light brightness in a small area. People who shoot with stage lighting can meter selected spots in highlight and shadow and compute a proper exposure between them. Numerous SLRs have built-in spot meters.

- Experiment with exposing pictures in contrasty lighting when the subject is suitable, such as a portrait or an outdoor scene when the sun is low. Contrast creates visual impact.

- The last time you attended an event in a large stadium or gym, did you notice spots of flash coming from the audience? Some people have not learned that flash built into a camera or from separate flash units is only effective when used from ten to about thirty feet from the subject.

LIGHT, FILMS AND COLOR

IF YOU ARE ANXIOUS TO GET INTO PICTORIAL LIGHTING, YOU COULD MOVE ON TO THE NEXT CHAPTER. IF YOU NEED MORE INFORMATION ABOUT COLOR TEMPERATURE AND ITS RELATIONSHIP TO FILM CHARACTERISTICS, AND WHAT TO EXPECT FROM VARIOUS LIGHT SOURCES, PLEASE STAY HERE.

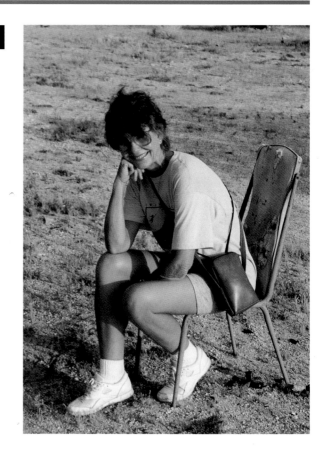

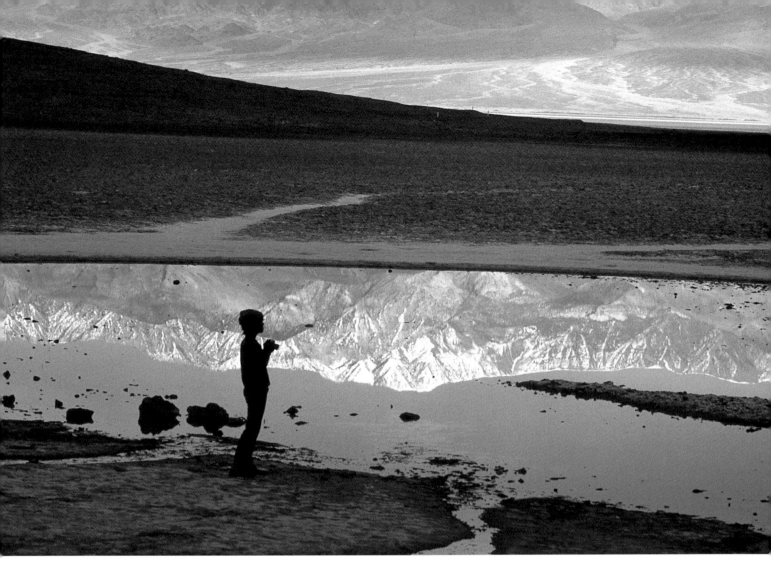

Opposite: Photography in daylight is easy these days (compared to the mid-1800s when there were no color films, cameras were always on tripods and black & white emulsion had to be painted on a glass plate). It's now easy to position a model on a random chair found in a desert setting in late afternoon and snap a picture with a simple background. Made with a Minolta point & shoot and Fuji 100 print film. **Above:** Before sunrise at Badwater in California's Death Valley, the color temperature of the light was probably a cool 8000K. My wife and I arrived early at this lowest point in the U.S. to catch a snowy mountain reflection contrasted with dunes, water and mudflats. Ektachrome 64 was the film in my Konica SLR on a tripod, and I exposed at $^1\!/_2$ second using a 35mm lens.

FILMS AND COLOR

Variations in Daylight. The films we use most are engineered for daylight or flash use, which means they are designed to show colors as you see them in daylight. Technically, the natural daylight spectrum of colors is ideally viewed in sunlight between about nine and three o'clock (in summer) when there are no clouds or fog. Time of day and weather create color variations that are recorded on film. For example, at sunrise and sunset, light passing through the atmosphere has a lovely warm tint. Photographers crave early morning and late afternoon light.

When it rains or the day is overcast, the light is cooler with a slight bluish tint that your eyes may not see, but your film does. Color in sun-made shadows is also bluish. In most daylight situations, with or without a warming filter (see page 34) over your lens, the color in

your pictures will be fine, because color is automatically corrected in prints, but not in slides. In some cases, a color correction filter can be useful.

COLOR TEMPERATURE

Daylight film shot in your living room using ordinary lighting fixtures gives you warm-colored prints and slides. Fluorescent lighting creates a greenish tint that film picks up.

Differences in the color of light are expressed in degrees Kelvin (K), also known as Kelvin temperature. In the nineteenth century, before color film, a scientist named Kelvin worked out a system to rate light waves radiating from nature's magnetic spectrum. His findings were related to heat, but Kelvin temperature numbers also designate the colors of light. A lower color temperature, such as 2900K, is warmer light. A higher number, like 8000K, describes cooler, often cloudy daylight. On the Kelvin scale, 5500K is the color film standard for average sunlight.

Tungsten photographic light sources are 3200K and 3400K, for which there are photoflood bulbs to match. Ordinary living-room lightbulbs are about 2900K, which explains why indoor subjects are so warm on slides and prints.

In warm or cool light, daylight color film can be converted to near the ideal 5500K by using filters. Bluish-tinted filters are used to raise color temperature. Warm-tinted filters are used to lower the color temperature of cold light, meaning it has a higher Kelvin number than 5500K. On page 37, you'll find a list of the basic filters used with daylight color slide films. Conversion filters may be used with negative (print) films, though color is usually corrected during printing.

CHOOSING
COLOR CORRECTION FILTERS

Overcast and Rainy Days. I especially hate cloudy days when I'm traveling, as there's a minimum of form and contrast in mountains, other landscape features and cityscapes, too. When shooting slides, warming filters can be used to prevent the blueish tints that flaw outdoor pictures. I use a 1A skylight filter or Tiffen 812 filter to warm scenes. But those filters don't magically make a flatly-lit subject without defining shadows into an appealing picture. While you need the sun, for close portraits, an overcast day can be welcome. See chapter 7.

Warming Filters. The skylight 1A is the most widely-used photographic filter. Its

COLOR TEMPERATURES OF PRIMARY LIGHT SOURCES	
Light Source	Color Temperature
Sunlight	5500K to 6000K
Electronic flash	5500K
Cloud light on overcast day	6500K to 10,000K
Photoflood bulb (for Ektachrome 160T)	3400K
3200K photoflood bulb (for Type B films)	3200K
100W lightbulb	2800 to 2900K
Candle flame	2100K

warming influence is mild and I keep one over each of my lenses for protection, even on sunny days. The warming influence of a skylight 1B filter is minimal but it will help protect lenses. A colorless UV filter will also guard lenses from scratches and dust. The 85B warms images noticeably, but its effect may give subjects in sunlight an artificial look. The 85 warms less than the 85B and the 85C less than other 85-type filters. To compare these effects, ask to borrow a few filters—whether from a camera shop or from a friend—and shoot similar outdoor pictures with each. Make notes about the order in which you used the filters, then compare the images and decide which effects you prefer.

- An FLD filter is essential to get rid of greenish tints from fluorescent light on daylight film slides. Experiment with one for color negative films, though print processors may correct for fluorescent lighting. An FLD filter may also make a pale sunset more dramatic.
- A polarizing filter can be revolved in front of the lens to reduce reflections from water or metal or to deepen blue in the sky. I've found a polarizer is seldom needed for deep-blue skies in the American Southwest, but it's valuable in areas where the sky is a medium pale blue. There's more about pictorial filters in chapter 5.
- Yellow filters in the 81 series are useful to help darken skies with black & white film, or for special offbeat effects with color film.

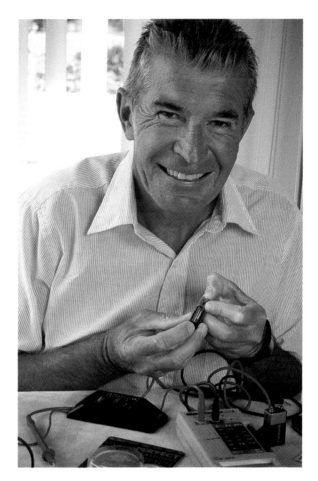

Robert Parker holds a battery tester, symbolizing one he invented that is sold with Duracell batteries. The art director of a magazine devoted to business opportunities asked for a warm, slightly tilted portrait. Rather than use a filter, I shot daylight slide film with 3200K floodlights, 500W each, which, without any filters, produced a warm effect with daylight film. The camera was a Canon Elan SLR with a 28–80mm lens.

Filter Advice. It's smart to start with a minimum of filters and add more when needed. With most slide films a 1A filter is a necessity, and a polarizer can be handy. Filters for greater warming like the Tiffen 812 are useful on overcast days, and an FLD filter makes shooting with fluorescent lights feasible. An

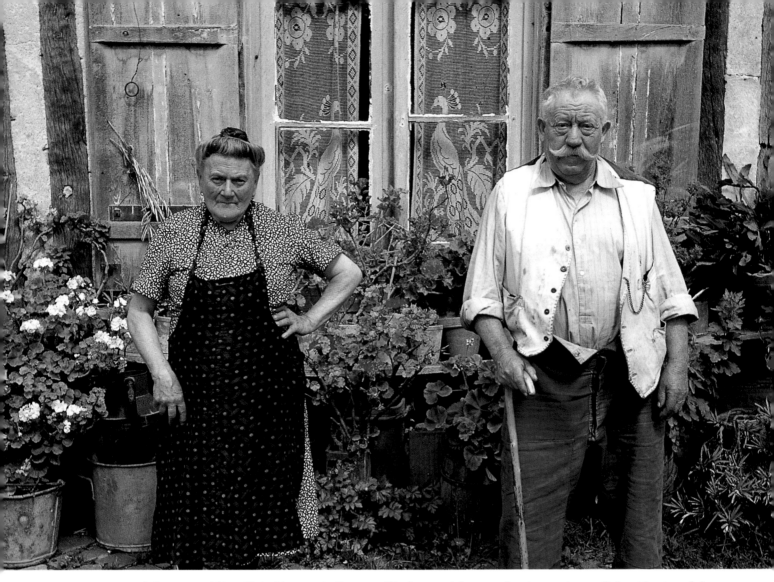

A farmer and his wife in Normandy, France willingly posed for me after I gave them a Polaroid print of themselves. On this cloudy day I warmed the picture with a 1A skylight filter over a 50mm lens on a now-vintage Nikon SP rangefinder camera. The film was Kodachrome, which has retained its color for many years.

80A or 80B filter with daylight film and 3200K lights is ideal for indoor photography, but pull the shades to shut out daylight. Filters for dramatic effect are discussed in chapter 7.

FILM NOTES

Negative (Print) Films. These films are very popular for point & shoot or SLR cameras because most people prefer looking at prints, and these films are color corrected in printing. Slide films are more temperamental and should be color corrected in the camera. If prints are not color corrected to your satisfaction by a mass-market processor, try a one-hour shop where you can see results and make suggestions. (Custom processing labs are discussed below.)

My experience indicates that mass production film processing and printing (film dropped at drug stores, supermarkets, etc.) is amazingly good in the twenty-first century because expensive equipment is controlled by printing personnel who are often quite skilled. But all processing services are not equal. A few

USEFUL PHOTOGRAPHIC CORRECTION FILTERS	
Filter Type	**Effect**
*Skylight 1A	Adds warmth in open shade and on cloudy days.
Skylight 1B	A pale version of 1A.
*80A	Blue; converts daylight-balanced slide films to 3200K lighting.
80B	Blue; converts daylight-balanced print films to 3400K lighting.
80C	Blue; converts 3800K to 5500K with tungsten Ektachrome.
81A	Yellowish; converts 3400K to 3200K.
81B	Yellowish; converts 3500K to 3200K.
82A	Blue; converts 3000K to 3200K.
82B	Blue; converts 2900K to 3200K.
82C	Blue; converts 2800K to 3200K.
85	Amber; converts 2900K to 3200K.
85B	Amber; converts 5500K to 3400K.
85C	Amber; converts 5500K to 3200K.
*Polarizer	Eliminates surface reflections on water and glass, and darkens blue skies.
*UV	Clear; absorbs ultraviolet light.
FLD	Corrects greenish tint caused by fluorescent lights.
Filters marked * are most commonly used.	
Camera metering systems compute exposure accurately for filters.	
Ektachrome 160 is a tungsten-type film rated 3200K for use with floodlights.	
Packed with Tiffen color filters is a small brochure listing all the above filters and more.	

years ago one of my wife's nice sunset print enlargements came back from a mass production firm with pale, washed-out color. We requested a reprint, and it was improved, but still lacked color brilliance. We took the negative to another mass processor drop-off point and finally received a good, color-saturated sunset image. Maybe the acceptable print was made by a more skilled and aware operator.

Custom Labs. As an alternative, we could have taken my wife's negative to a custom processing lab where individual attention is given to each enlargement and technicians are theoretically more experienced. When you take your film to a custom lab, expect your prints to cost more than they would if taken to a mass-market drop-off point. To find a custom lab in your area, check the yellow pages, or call a professional photographer for a recommendation. Many wedding and portrait photographers select custom labs in other towns because of their expertise and reasonable prices—and you might try one, too. Of course, you may prefer to deal with a lab in your area as you can benefit from face-to-face dialogues about the qualities of a good print.

One-Hour Labs. Another processing alternative is a so-called one-hour lab. Most will

Right: When my son Barry Jacobs was in Scandinavia he walked many of Bergen, Norway's residential hilly streets with fine views. He isn't sure what time this was taken because, he says, "In summer the days can last 20 hours." For protection Barry keeps a UV filter over his Tamron 28–70mm lens, which he used on a Leicaflex. The film was ISO 200 Kodak negative film. **Below:** Photographing master furniture maker, Sam Maloof, in his workshop finishing a $2,000 rocking chair, presented a mixed-light dilemma. I corrected fluorescent lights with an FLD filter, and to boost the light level I added three 600W, 3200K quartz lights. Daylight from small windows had little effect. The whole shop took on a pleasant warm tint on Kodachrome 64 film, which I used in an SLR with a 21mm lens.

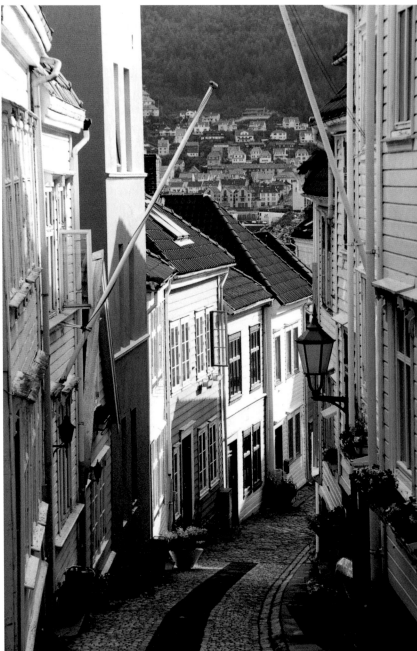

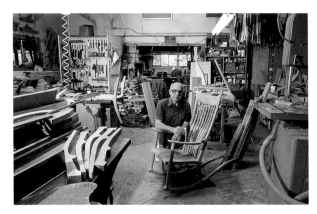

enlarge your negatives whether they developed the film or not. A few technicians I've known at one-hour places own their business and have lots of experience with color printing. I once took badly printed negatives I shot (on ISO 100 print film) of paintings copied with 3200K lights and an 80A correction filter to a one-hour shop. Previous prints had been blue-tinted. While I watched, the one-hour lab operator made several test prints with varying filtration until he got the color I wanted. While many prints include outdoor greens or flesh tones as standard colors, an operator can't easily guess the colors in a painting. If

you copy artwork, take the work to a one-hour shop as a precaution. There's more about matching light sources to film when copying in chapter 7.

Slide Films. As mentioned previously, slide films are more exacting than print films, and seem to be used most often with single lens reflex cameras. Point & shoot camera makers do not provide ways of attaching filters to lenses, nor do many point & shoot cameras include exposure adjustments. Filters can be mounted on SLR lenses, and with some you can see how a subject is affected. The filter chart on page 37 applies mainly to shooting

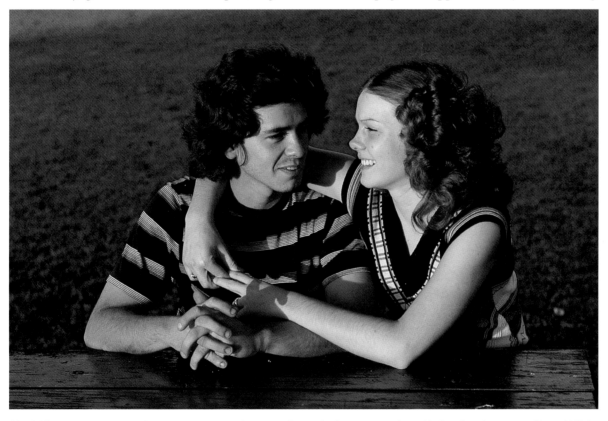

Ken Whitmore is a specialist in corporate photography and often uses colored lights for dramatic effects. While strolling in the vicinity of his home near sunset, Ken met this couple sitting at a picnic table that had a welcome dark background that contrasted well with flesh tones. He photographed them using a Nikon F4 and Kodachrome 100, and they signed a model release in return for prints. Ken actively shoots stock pictures that are leased through a stock agency.

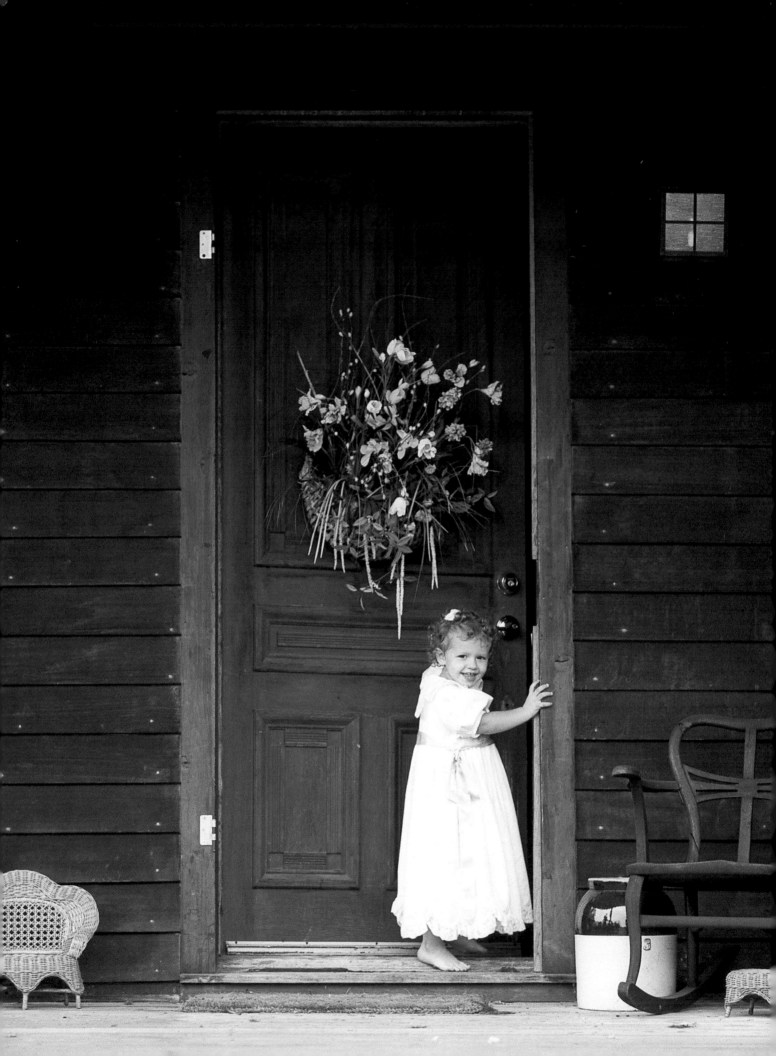

slides when you want to correct color or improve it for emphasis. If you shoot negative color film in an SLR, you may benefit by using the 80A, the FLD and a polarizing filter. Test these filters and let processors know what you used so they don't have to guess about filtration to give you good color. Ask to inspect the prints if you wish.

ODE TO BLACK & WHITE

When photography was invented, pictures were colorless on metal or glass plates. Sheet film and roll film didn't come out until the late 1880s, along with handheld cameras. Thereafter, photography began its great rise in popularity. By 1936, Kodachrome became available for slides, and a year later Kodak introduced three new 35mm black & white films. Not until 1963 did Kodak offer Kodacolor print film, which was improved frequently. In those days, commercial color negative processing cost more than black & white processing, a situation that has since been reversed because so little black & white is used.

College photography courses may still include black & white techniques, because processing and printing your own pictures provides helpful understanding of exposure, composition (via cropping enlargements) and basic disciplines. Students move on to color photography, but some fall in love with black & white. As a well-known musician said recently, when his father used the young man's bedroom as a darkroom, "It was complete magic to me."

Black & white pictures have always had their own mystique. Some of the finest black & white photojournalism has been done by distinguished people like Sebastian Selgado and W. Eugene Smith.

Much fine art photography continues to be black & white, in the tradition of Edward Weston, Ansel Adams, Wynn Bullock et al. Here are some lighting-related reasons for loyalty to black & white:

- It requires you to use your imagination about colors, which the film converts to tones of gray.
- Strong, moody pictures in black & white can be lit with more contrast than in potentially "pretty" color. Shadows don't always have to be filled. Find a book of Edward Weston or Ansel Adams images to see visual poetry.
- Black & white film processing is easy in a home darkroom. Enlarging negatives is a constant challenge, because quality prints are not easy to make. Color processing and printing is even more complex.
- It's so easy to turn color film over to highly automated, usually excellent color processors, that it's understandable that a large majority of us enjoy shooting color. Besides, our friends, relatives and clients expect color images.

Should you choose to try black & white photography without a home darkroom, Kodak, Ilford and Agfa all offer chromogenic 35mm black & white films. These films are processed in color negative chemistry, but provide black & white prints.

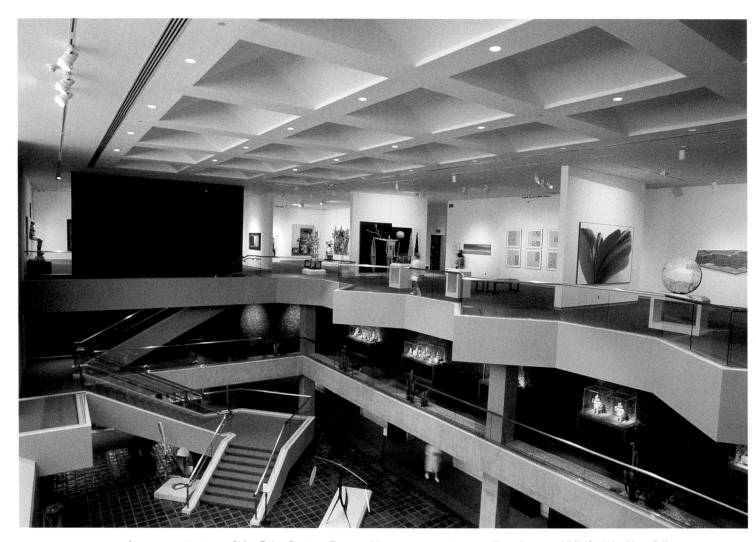

A panoramic view of the Palm Springs Desert Museum was taken on Ektachrome 100VS slide film. Off camera, there's a large vertical skylight at the left, with tungsten lighting in the ceiling and in display cases. Daylight cooled the warm light just enough to capture the museum's appealing appearance without any filter. I used a 21–35mm zoom on my tripod-mounted Canon SLR for good depth of field at one second at f/16.

PHOTO PROJECT

Shoot a room where reasonably good daylight comes from windows, doors or skylights, then do the same views in the evening with artificial light. Use print film and a tripod if possible to position your camera. Include various light sources at night, and maybe a window during the day. Turn off the flash in a point & shoot, and use a night setting if there is one. Choose a slow shutter speed, such as ½ second with an SLR. In either case, choose viewpoints that include a range of tones, day or night.

Shoot without a filter, and also with an 80A or 80B filter (borrow one at first if possible) over the lens, and repeat some of the pictures. With a point & shoot camera, try holding a large gelatin filter in front of the lens. Note on your processing order the filters used. Unfiltered prints (or slides if you prefer) may include quite warm areas at night due to the color temperature of artificial light. Pictures taken with an 80A or 80B blue filter should be less warm. Notification about filter use is unnecessary for slide processors.

For further comparison, when shooting at night, aim an electronic flash at the ceiling, and also directly into the room, for a few shots with and without the filter. For another exercise, photograph a kitchen or any room with fluorescent lighting, with and without an FLD filter. Discover if the filter prevents the greenish fluorescent tint. Make filter notes and transfer them to your prints or slides for valuable future reference.

THE LANGUAGE OF LIGHT

HERE ARE A FEW TERMS THAT DESCRIBE DAYLIGHT AS WELL AS APPLIED LIGHT, THE ELECTRIC-POWERED KIND.

TERMS FOR LIGHTING VARIATIONS

Direct Light. This type of lighting points directly at the subject from a variety of angles. Our universal light source, the sun, is *direct* whenever it casts noticeable shadows. The flash in or on your camera is also direct, unless you diffuse it into an umbrella, or bounce it (see below).

Reflected Light. Also known as indirect or bounced light, this type of lighting is diffused and softened by reflection. This is the principal alternative to direct light. If you don't have a reflecting umbrella and there's no suitable surface outdoors, use a handheld reflector. I suggest white illustration board in 30x40-foot sheets. A full sheet may be adequate to reflect light on a small group. For individuals, cut smaller reflectors from the larger one. Have someone hold a reflector where you want it, or

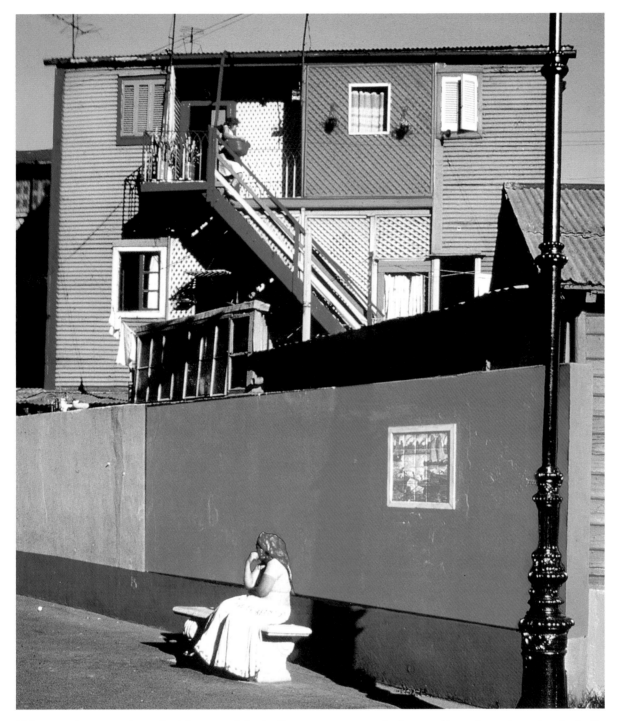

Where is the sun in this colorful image of the La Boca gypsy quarter in Buenos Aires, Argentina, taken by Lydia Clarke Heston? "It seemed like an abstract painting," Lydia says, adding, "and I composed the picture's areas of color as though Mondrian had created it in an off moment." She shot Kodachrome in a Leicaflex with a 35mm lens, and later scanned the slide to make a print. The sun's position is indicated by the shadow of the black pole at right and the shadow of the stairs.

if you work alone, tape or tie a reflector to a light stand, or rest it on a chair. Consider colored illustration board to reflect warmer color on subjects.

Many of the most beautiful and appealing pictures seen in print are taken with reflected or indirect light. This is especially so for people pictures, many kinds of still lifes—like glass or silver—and for all subjects that look well in soft light, which means light that casts no shadows, or only soft-edged shadows. Look at product photos and editorial images in magazine ads or newspapers. Most are taken in studios with electronic flash and umbrella reflectors or softboxes that diffuse light. Some news portraits are taken with diffused daylight from windows, occasionally augmented by reflected flash. I want to encourage you to experiment with diffused and reflected light using manufactured or improvised gear. Think of indirect light as smooth lighting.

LIGHTING SOURCES

The term *hot light* describes incandescent light sources, such as photofloods and quartz lights, that get very hot. They are popular because you see what the lights do before you shoot. Fluorescent lighting stays cool, but it has no red in its spectrum and turns things greenish on film, so it's not a good light source for color pictures.

Electronic flash, also referred to as strobe, is available in many sizes and types. Small flash units are built into most point & shoot and SLR cameras. Photographers often mount more powerful portable units atop their SLR cameras to cover greater distances. Studio strobes operate on AC or storage batteries and

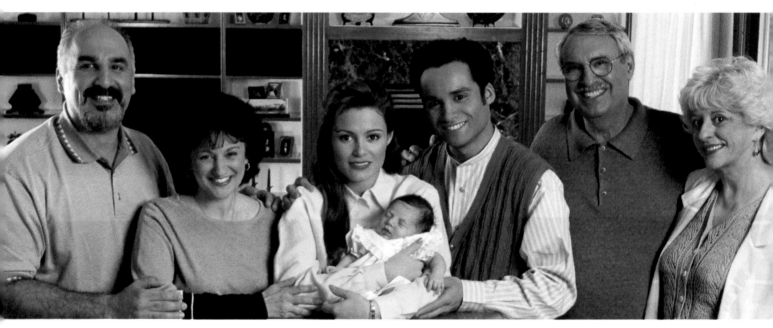

A Kodak photographer shot this smoothly-lit panoramic picture with electronic flash in a living room. A 2000WS strobe was likely used in a softbox, which was placed from the right at a distance to cover the family group. It was high enough so shadows disappeared behind the subjects. A smaller flash lit the man at left from the side. Taken to illustrate the panoramic camera format, the picture is used courtesy of Eastman Kodak Co.

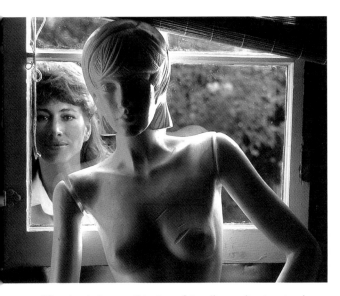

The back-lit manikin in a friend's studio inspired me to pose her behind it in the window. It was an offbeat photo opportunity for which I used an SLR with a 35–70mm lens and Kodachrome 64. A tripod helped me make a precise composition, and I didn't use flash fill, as it would have upset the picture's impact.

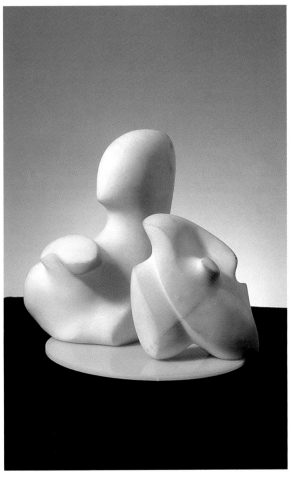

One floodlight above and at the side of a small sculpture created shadows to define the forms Mark Sink carved in marble. At the left was another floodlight reflected into an umbrella to fill the shadows, and aimed at the background was a 150W flood bulb to separate the sculpture from the background. For this delightful sculpture, only seven inches high, I used a 28–80mm Canon zoom on my tripod-mounted SLR. An 80A filter converted 3200K hot light for use with daylight-based Ektachrome 100SW.

usually generate much more light than popular portables. Modeling light is an incandescent light built into studio electronic flash units to show how the flash will illuminate a subject.

DIRECTIONAL LIGHTING

Back Light. This type of light comes from perhaps a 100-degree arc behind a subject to create vivid images. It may also appear as a halo around a subject's head. Back light separates subjects from backgrounds, and it adds an accent to a picture. Outdoors, when the sun is behind someone, it's easy to brighten the person from the front with flash or a reflector. The process is called *flash fill*, and it's routine to turn on flash for back-lit scenes and portraits. But some back-lit situations don't need flash fill, such as the woman outside her studio with a shadowed manikin in the foreground. Flash would have ruined the manikin's pictorial impact. Back light on the edges of a subject is called *rim light*, which you see on the manikin's face and arm.

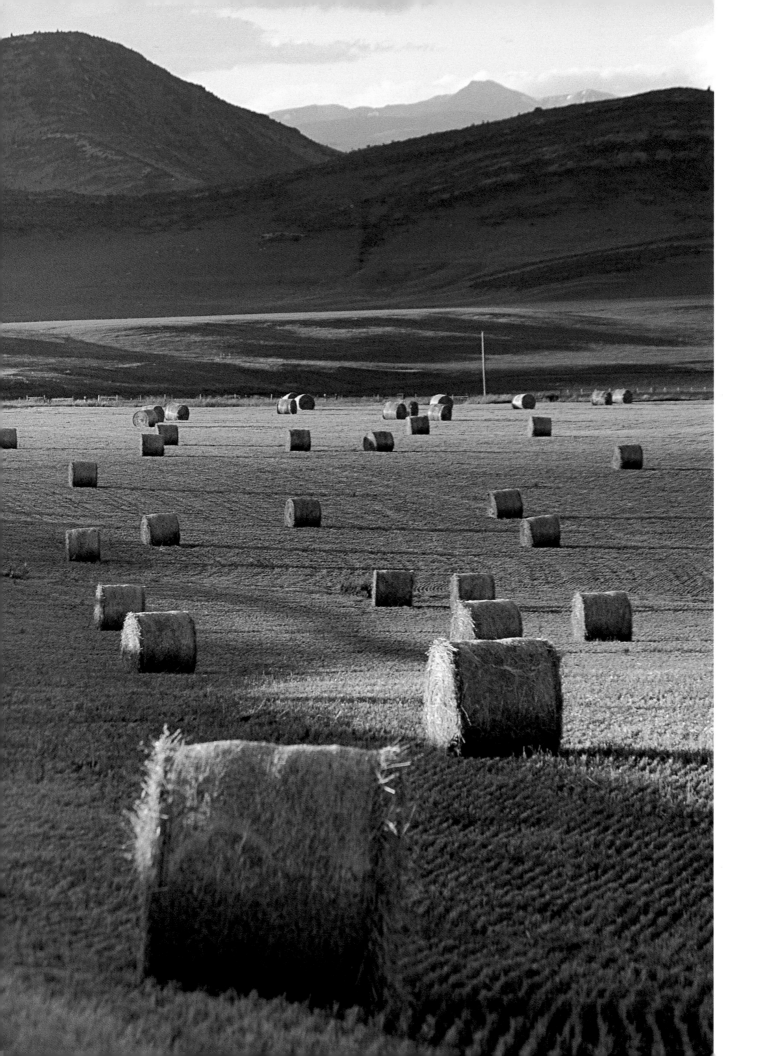

Side Light. It comes from one side of a subject and often adds a graphic accent to images. In some cases you may use flash fill that's weak enough so the side light effect doesn't disappear. Side lighting from the setting sun was a fortunate find on a field of hay bales in Montana. This artistic effect lasted maybe ten minutes, and I took six or eight pictures, zooming to various focal lengths. Careful side lighting also works well on portraits, still lifes and other subjects.

Top Light. This light casts shadows under people's noses but helps show form for some subjects. Most sculptures look good when lit from the top, and in the photo on page 47, a floodlight was placed top right and fill light was reflected to brighten shadows. In summer, high sun is non-flattering top light, causing

Opposite: I found this example of side lighting about thirty minutes before sunset near Three Forks, MT. Luckily, I was able to park safely and shoot from a nearby rise with a Canon Elan SLR and a Canon 75–300mm IS lens. The "IS" stands for image stabilization, which allows me to get sharp shots without a tripod at $^1/_{60}$ sec. At f/11 the depth of field was okay on Ektachrome 100SW. I could have set up a tripod, but the sun was disappearing rapidly. **Top:** Top lighting from the sun was okay for a strong face that benefited from the shadows. I met the man on a pier and asked him to pose. On the SLR camera was a 28–80mm Canon lens and the film was Ektachrome. **Bottom:** I titled this "Youth and Age in Daytona Beach." Side lighting does a good job of separating the ladies' figures from the background. I was using Kodachrome in an SLR camera with a 35–110mm zoom lens. This could have just as easily been taken with a point & shoot camera. The trick is to get the women large enough in your negative or slide.

subjects' eyes to disappear in dark pools. High sun also fails to show off natural forms like mountains, which are more striking when lit with side light.

Forty-Five Degree Light. Light originating from about that angle is popular for portraits and still lifes. Don't be too literal about the angle. Outdoors, the sun is often at about 45 degrees in winter, fall and early spring when it doesn't get as high as in summer. If you're not sure about sun angles for photos, take time to observe and shoot some test pictures of people and places for reference.

KEYS AND CLOUDS

High Key Lighting. This term describes a situation that is almost uniformly bright, such as Tammy Hoya's delightful photograph of a little girl in a white dress on a white chair with a light-toned background. The child's face, arms and legs provide welcome contrast in this studio setting. You'll see high-key pictures in fashion magazines especially.

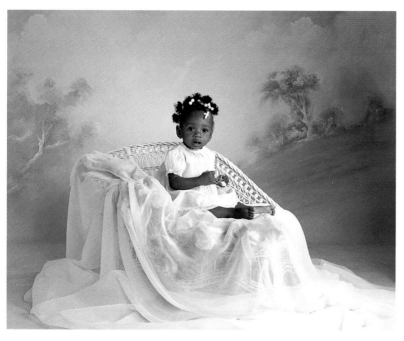

Low-Key Lighting. This term describes a situation dominated by dark tones, such as Ken Whitmore's photograph of a man working in a paper mill (opposite), part of a series for an annual report. A theme of the series was low-key pictures. Low-key lighting is used fairly frequently in movies as noted in the sidebar on page 53. We see less low-key lighting in advertising or magazine illustrations because it connotes gloom, and art directors usually want cheerful lighting.

A cloudy sky or overcast light can be a scourge or a blessing. Without sun, landscape pictures are usually boring because mountains, fields, buildings and most outdoor forms need shadow accents to be three-dimensional. I shoot many stock landscape and cityscape pictures that are leased through various stock agencies that prefer sunny pictures for their

Left: A high key image by Tammy Loya, a specialist in photographing children in Ballston Spa, NY. She told me, "I placed the child in a Wicker by Design christening bench and added a soft flowing fabric under which were silk flowers. The background was hand painted, and I used four Photogenic electronic flash studio units, the main one in a 24-inch softbox to diffuse the light." Tammy shot with a Mamiya RZ medium format camera and Kodak PRN negative film. **Opposite:** Ken Whitmore's moody image of a man at work has an artistic feeling found in paintings. This was taken with a single diffused electronic flash unit, the dark image seen atop the photograph. Because a wide-angle lens was used in a tight setting, Ken had to include the flash unit on which he placed an orange gel (short for gelatin filter). Ken shot with a 4x5 view camera using a 90mm lens, and made varying exposures, including underexposure, to achieve the eye-catching dark-toned effect.

Right: Bright shade on a clear day is a favorite type of light for still lifes and portraits. For this image, I spread a black cloth on a table and up a background wall and placed a real pear and strawberries with fake grapes. I then moved close with a 28–80mm Canon lens on a Canon SLR loaded with Ektachrome 100SW film. I recommend still lifes as a useful and expedient way to practice lighting and composition.

Above: When my wife and I visited Claude Monet's gardens in Giverny, France, in 2000, we found the grounds are kept as Monet planned them. While we were there the weather was cloudy, so I did not get suitable pictures of Monet's famous water lily pond in the overcast light. As we were leaving, the sun peeked out and I photographed a side-lit flower-bordered green lane visible from Monet's house. It was taken with a 21–35mm zoom and Kodak 100VS slide film.

buyer appeal. When you travel, finding the patience to wait for the passing of rain or clouds at scenic sites is essential.

Finally, there's open shade, the often delightful bright-cloudy light for individual portraits or groups. In open shade people don't squint, and the light is usually smooth, the equivalent of diffused hot light or electronic flash. When shooting portraits, if there are no clouds, and the sun is uncomfortable, a shady spot, preferably opposite a wall or other reflective surface, can produce versatile lighting conditions.

LIGHTING TIPS

• When I suggested you observe various lighting effects I recalled two series of paintings by French artist Claude Monet (1840–1926). In one series he painted Rouen's Gothic Cathedral of Notre Dame in France—thirty times—to show how the changing light affected its façade. In the other series he painted haystacks in the varying light of the four seasons. Some of the cathedral paintings are soft and ethereal when the façade was in shade, though the haystacks are seen in sun with shadows symbolizing the changing daylight. Look for reproductions of Monet's well-known works in books to better understand how this great artist interpreted lighting phenomena.

• Consider making your own series of outdoor lighting photographs as a day progresses. Pick a subject in a location convenient to get to, such as a church with character in its façade, or a nostalgic street corner or a rural setting. Shoot over a period of time and use a tripod; mark its location to frame the same composition each time you show how changing light modifies the subject.

• While watching movies and television, observe how people, interiors and exteriors are lit. Cinematographers have wide lighting latitude but light must suit the story, the setting, the mood and the actors. Look for subtle changes. I recently saw a movie titled "Finding Forrester," which included many effective low key scenes of a black teenager in near total darkness. Viewers sometimes had to imagine what was happening. Near the beginning of the movie there's a fascinating foggy scene, too. Motion picture and TV still photographers (who shoot publicity pictures) have the advantage of working with experts at lighting and their still images include lighting accents we may envy. Try some subtle mood lighting around home.

• Explore: To see firsthand the equipment that creates soft or directional light, try to arrange a visit to a professional photographer's studio. Ask friends for photographer recommendations or use the telephone book for sources. When you ask permission to observe studio work be tactful but persuasive. Chapters 5, 6 and 7 contain additional information on reflector umbrellas and softboxes, including ideas for photographing in your home "studio."

Right: Kathy Jaeger, a graphic designer, swears she didn't add any fill light for this glowing portrait of a father and child. When you do find natural lighting as bright and smooth as this, exploit it. Kathy used an SLR and print film. **Below:** Sand dunes like these in Death Valley, CA, must be photographed in early morning or late afternoon, as pictured here, when the sun is low enough to show their rhythmic forms. Prepare to trudge up and over sinking sand looking for good compositions—the effort is worth it. Taken with a Canon SLR, 28–105mm lens and Ektachrome. I didn't need a tripod, which sinks easily into sand.

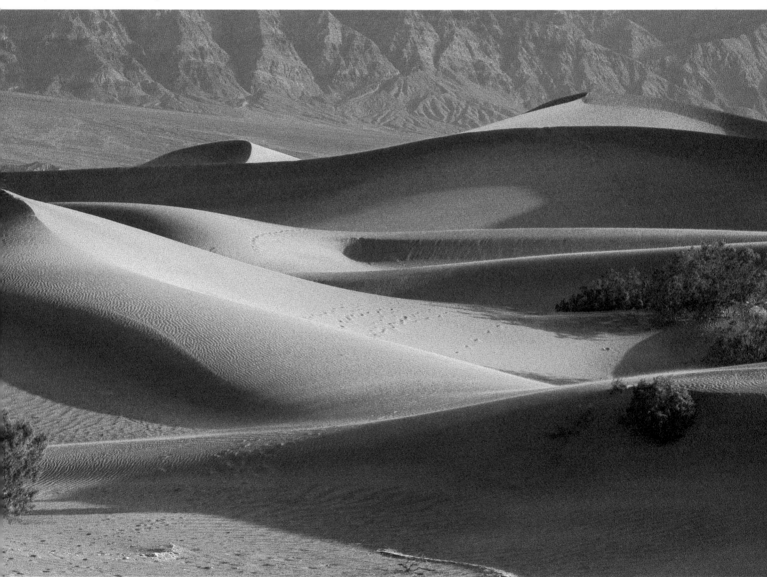

LIGHT AFFECTS FORM AND MOOD

- Study sun lighting and shadows. Observe room light at home, lighting in the mall, or wherever you are. If you're not taking pictures with a camera, take them in your mind.

- Analyze photographs of people, places and products in magazines and newspapers. If you need more magazines, check the library or the offices of your doctor and dentist. Imagine how photographers placed their lights in images you like.

- Study how scenes are lit in movies. Look at people and places. Are they mood lit or is lighting used to illuminate story and action? Are dark places dangerous and bright settings cheerful? Do movie makers modulate the light to obscure what they don't want you to notice?

- Have you learned to "read" shadows in outdoor photographs? Just as a sundial indicates time, pictorial shadows show you the direction and location of lighting. Hard-edged shadows are emphatic, soft shadows are subtle and an absence of shadows indicates diffused lighting. Some portraits are so evenly lit that they defy you to guess where the light sources were. Look for reflections of reflector umbrellas and softboxes in people's eyes.

- Clip examples of lighting you like from magazines, and make a reference scrapbook.

The more you photograph in various types of light, the better your skills and pictures become.

PHOTO PROJECT

To study the ways light can be explored, shoot a series of portraits—or still lifes if those are more accessible. Ask someone to model for head & shoulders pictures. Use a tripod to keep the camera in one spot while you arrange lights. If you don't have a tripod, inexpensive models are available at camera shops or discount stores. Refer to chapter 6 for equipment suggestions: Use two hot lights and ISO 200 or ISO 400 print film with and without filters. Try 80A and/or 80B blue filters for comparison, and alert the processor to which was used. Shoot plenty of film. You learn as much from mistakes as you do from success.

Note: Lighting pictures of a model appear in chapter 7 if you want a preview.

Place your model two to three feet away from the background. Make a series of pictures with lights in each of the following suggested positions:

- Light the background for contrast with a separate hot light, such as a 150W bulb, low behind the model.

- One light above the subject from the front, and another from one side to brighten shadows.

- One light from one side and another from the other side, direct or reflected from an umbrella or piece of illustration board, to brighten shadows. Adjust the lights so shadows are pleasant.

- One light at a 45-degree angle and another direct or reflected from the other side to brighten shadows.

- One light from one side or the other, behind the model, and another light in front, preferably reflected.

- Do similar exercises with a still life setup. Set it up where it won't be disturbed so you can shoot when you wish. Doing your own lighting exercises, you don't have to justify the pictures to anyone.

Those are basic lighting techniques. Learn to control shadows and flatter the model. Be resourceful. Your prints will be valuable references. To learn advanced lighting techniques, refer to *Posing and Lighting Techniques* by J. J. Allen (Amherst Media).

Driving highway 395 on the east side of California, I came upon a large herd of sheep slowly being driven by a sheepherder whose mission was to see that the animals chewed the grass fairly evenly. Back light dramatized the scene, which I shot with a 75–300mm zoom on a Canon SLR. I made numerous exposures because pattern pictures are addictive, and success in getting a strong composition is not guaranteed.

DAYLIGHT

MORE PICTURES ARE TAKEN IN DAYLIGHT THAN WITH ANY SORT OF MAN-MADE LIGHTING, PROBABLY BECAUSE SHOOTING OUTDOORS IS SUCH A PLEASURE.

OUTDOOR OPPORTUNITIES

Daylight permits photographers to choose from a large range of exposures for action, people, and an unlimited list of subjects. In fact, it's so easy to snap pictures in sunlight or under cloudy skies that many otherwise conscientious photographers tend to become careless. That means they snap away without thinking thoroughly enough about camera angles, facial expressions, suitable backgrounds or eye-catching compositions. As an enthusiastic friend told me when he showed me some prints, "I was so into catching the whale leap out of the tank, that I neglected zooming closely enough." No matter how great the light, photographic technique is meaningful.

A Sunday market in Guatemala was a welcome find as we drove through a village where I found a pageant of activity in the small area. No one seemed to mind my taking pictures. This is my favorite because of the way people and background filled the composition. The camera was a Konica FT-I, which is no longer made. A bright overcast day was warmed by a skylight IA filter on a 70–150mm lens. The film was Kodachrome 64. It's a better picture than it would have been with sun and harsh shadows.

SCENIC LIGHT

Scenics and cityscapes, waves breaking on photogenic rocks or a wonderful old leaning barn can easily become favorite subjects for daylight shooting. Professionals seek out scenic situations where light dramatizes landforms and intensifies color. Those of you who take pictures for personal pleasure and self-expression can also hype yourselves to find photo opportunities. Be sensitive to directional light, and changes in intensity or color variations when the sun is low. If time allows, wait for better light. If that's not feasible, return to the scene when you anticipate better photographic light.

Too often I face a conflict between keeping a travel schedule and staying to wait for improved pictorial light. I sometimes have to persuade myself to wait fifteen minutes until clouds pass or the light changes. I'm convinced, and hope you are too, that the aesthetic accent of warm morning and evening light is worth waking early, or waiting for day's end to shoot. The urge to do other things often conflicts with the desire to shoot in ideal light.

It's usually too easy to point a camera at an outdoor subject and assume your enthusiasm assures a worthwhile image. Only rarely am I

WHERE MOST OUTDOOR PICTURES ARE TAKEN

On the Road. We get turned on to taking pictures of natural and man-made subjects while traveling, and we need to shoot in all kinds of light. When there's opportunity, arise early to catch the beautiful light of dawn. Stick around at day's end for warm light at dusk and sunset. I'm addicted to shooting in bright sun, because most stock agencies want sunny scenics. I do take pictures in lighting conditions that may not be acceptable for stock shots, but could be useful in my books.

Some of the best scenics are made using a tripod—bright light or not. Even if you have time limits, as I sometimes do, take time for tripod shots when slower shutter speeds make handholding a camera risky. Use a tripod, also, when depth of field is important and small apertures require shutter speeds slower than $1/60$ or $1/30$ second. Choose a lightweight tripod that isn't a chore to carry. You don't have to pay a fortune for a good tripod, which I'll discuss in the next chapter.

In case you forgot, depth of field is the area between the nearest and farthest objects or subjects you want to be in sharp focus at a given f-stop (a.k.a. aperture or lens opening) and focusing distance. The smaller the f-stop, the greater the depth of field from a specific distance. The larger the f-stop, the less the depth of field from a specific distance. Depth of field at a specific f-stop decreases as you move closer to the subject. For close-ups, increase the depth of field by choosing a smaller f-stop like f/16. Depth of field is also strongly influenced by lens focal length. It is greater with a 28mm lens focused at eight feet than for an 80mm lens focused at the same distance and f-stop.

Note: Many SLR cameras offer depth of field preview through the finder. You can't check depth of field through a point & shoot window finder, but you can anticipate that it will usually be suitable in bright light, especially with an ISO 200 or faster film.

Around Home. When photographing posed or active family or friends, children playing, or the events of daily life, remember that the brighter the light, the faster the shutter speed—and the smaller the f-stop a point & shoot camera sets. Portraits in bright shade or reflected light can be elegant, and depth of field usually doesn't matter. Posing someone near a window and reflecting light into their shadow side, or using flash fill, can also be very effective. On a cloudy or rainy day, moody picture situations might occur. When you are inclined, make the best of the light and try flash fill to brighten portraits.

At Social Events, Parties, Weddings and Other Celebrations. When photographing these occasions in bright outdoor sunlight, you can grab pleasant expressions, though open shade on a roofed porch is easier on peoples' eyes, and you avoid harsh shadows. In many point & shoot cameras the flash turns on automatically in shade, but when a subject is back lit, turn the flash on manually. For an outdoor wedding, consider erecting four poles. You can mount diffusing fabric on them to shade the bride, groom and clergyman.

Other Subjects and Occasions. At backyard swimming pools, at the zoo, on picnics and at outdoor parties, daylight shooting seems effortless, but be sure to pay close attention to composition. Group pictures and portraits are also popular. Find shade or turn people with their backs to the sun (continued)

(continued from page 59)
and use flash. When faced with a variety of lighting situations, choose scenarios that make the best pictures and keep people comfortable at the same time.

Practice Photographic Patience. Seek better vantage points to turn outdoor situations into more appealing images. Wait out passing clouds or shifting shadows. Anticipate the pictorial value of sun from lower angles in winter. High noon summer sun does little for most subjects, but look for shadow areas in winter when the slanting sun adds pictorial advantages to outdoor subjects, especially scenics.

sure I'm getting a classic image, as I was when I shot the beach with gulls (see page 62).

Along with waiting for the right scenic light, it's usually necessary to find alternate viewpoints to improve scenic pictures. I make the effort to shift to new views as often as possible because it's too easy to be careless. Don't develop the mind-set that beautiful light is enough. Take time to think about composition, timing, backgrounds and other pictorial qualities when creating your images. Landscapes, seascapes and cityscapes are not only wonderful souvenirs of travel, but they hold

Top Left: Enthusiastic musicians played at a summer fair in Laguna Beach, CA, and high, bright clouds created soft light. I moved as close as possible and checked the depth of field as I focused a 28–80mm Canon lens. With Ektachrome (ISO 200), I shot at $^1\!/_{60}$ second between f/8 and f/11. The two men in back are not as sharp as the two in front, but my tripod was not handy. Sufficient depth of field is often compromised in shady light without a tripod. **Bottom Left:** It was afternoon in late summer in San Francisco when I photographed across Yerba Buena Gardens at the downtown area, including the Museum of Modern Art (the tan building at right). High side light shows off buildings well, creating shadow accents to separate them. I shot at f/16 to assure full depth of field. Study clusters of photogenic buildings and decide when the sun will be best for pictures. Taken with a 28–135mm zoom on Ektachrome 100VS.

Nyhavn, a well-known street in Copenhagen, Denmark, where Hans Christian Andersen once resided. The harbor is actually a canal dredged 300 years ago to draw commerce to the city center. Once the favorite haunt of sailors, it's now gentrified with restaurants and stores, and people congregate along a row of colorful buildings that I happily found in bright sun. I shot this image with an SLR and 28–135mm zoom on slide film.

the promise of becoming attractive framed enlargements. Be resourceful in using pictorial light to help guarantee outstanding pictures.

CHIAROSCURO

The term *chiaroscuro* describes the light and dark effects that classic painters used to dramatize their indoor and outdoor scenes and portraits. Here are two dictionary definitions of chiaroscuro: (1) The use of deep variations and subtle gradations of light and shade to enhance dramatic pictorial effects. (2) The distribution of light and shade in a picture. (Light and shade are also known to photographers as highlight and shadow.)

Rembrandt was a master of chiaroscuro, as were numerous other old masters. Ansel Adams made valuable use of chiaroscuro in

On our first morning in Salema, a village in southern Portugal, from a hotel window I watched the sun appear on the adjacent beach. Warm light quickly drew me to the beach with my Canon SLR, where I photographed back-lit gulls. Then, in the distance, I saw a large cluster of gulls enjoying the incoming tide, and turned my attention toward them. Starting to shoot with a 75–300mm zoom, I walked closer and, after switching to a 28–135mm lens, I went on a quiet shooting spree. The birds shifted in the glorious light to make new compositions, and in five minutes I had a full 36-exposure roll of 100VS Ektachrome. I got more on a second roll, realizing that seductive early sun had made possible special images.

his black & white landscape photographs. When you are photographing nature or people, do you look for unusual light and shadow effects? We're talking about strong tonal contrasts that create visual drama. Outdoors, search for or wait for the right light. Indoors, arrange the lights for portraits or still lifes, using highlights and shadows to achieve attractive contrasts.

SHOOTING INTO THE LIGHT

Posing people with sun or bright clouds behind them can create silhouettes, which are a valuable way to obscure a messy background. But the usefulness of silhouettes is limited, so we brighten subjects with flash fill or a reflector. Flash built into cameras does an excellent job of illuminating back light shadows, especially at distances from three to maybe ten feet depending on the camera, lens and flash. For more distant back-lit subjects, mount a stronger flash on an SLR camera. Remember also that the faster the film, the more effective your flash will be, as camera and flash instructions booklets detail. So ISO 200 or 400 films are practical for groups and subjects ten or

twelve feet away. ISO 200 print film is very versatile. ISO 400 print films are not likely to show grain in 8x10 prints, and also maintain good contrast. Films faster than 400 tend to have slightly softer colors and contrast, an asset in some lighting situations.

If flash fill is not available, a white illustration board reflector also brightens dark areas created by shooting into the light. At an art supply store buy a 30x40-foot sheet and use it as is, or cut it to convenient sizes. Have someone hold the reflector at an angle to illuminate faces or whatever. If reflected sun is too bright for someone's eyes, place the reflector farther from the subject or use flash fill.

Separate Flash Units. Companies that make single lens reflex cameras and independent companies both offer electronic flash units

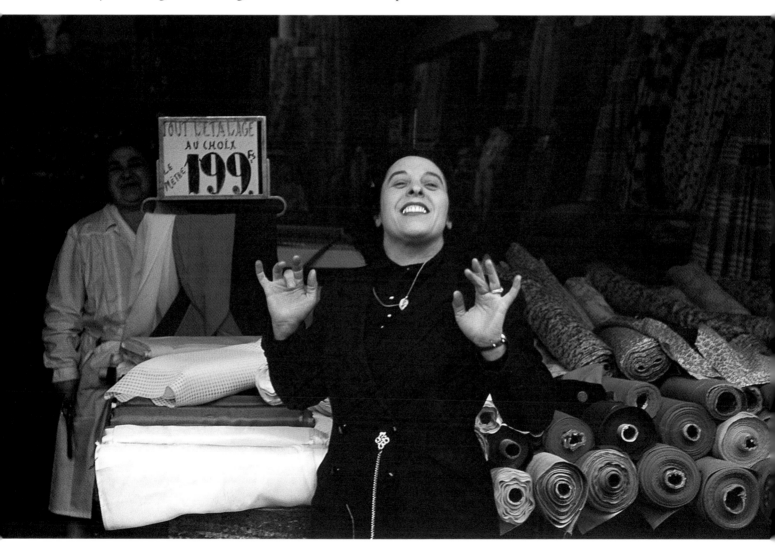

There is moody light and a dark chiaroscuro effect in this image of a woman who was delighted to be photographed in Paris a few decades ago. Light was reflected from across the street and Kodachrome 64 caught the spontaneity. My camera was a rangefinder Nikon SP with a 50mm lens. Kodachrome is still valued for its longevity, but Ektachrome and other films have equaled it for color stability.

Above: The light was behind Ainsley when Jim Jacobs (my nephew) moved close with his SLR to capture her pensive expression. Ainsley's portrait didn't need flash fill because light was reflected from a nearby chair cover. Flash would have spoiled the pastel coloring recorded by Kodachrome and a 28–105mm lens. Jim cropped closely in the camera and kept the background simple. **Opposite:** Backlighting was strong when I looked down a narrow street in a French town, the kind of setting so prevalent in vintage European cities. With just a glimpse of the ladies, there was only time to raise my Canon SLR with 28–135mm zoom lens and shoot two frames. Luckily, this rim-lit (a type of back lighting) image was suitably composed because I don't remember zooming the lens. The picture demonstrates chiaroscuro drama on ISO 100 slide film.

that slip into the accessory shoe atop an SLR camera. Most are automatic and compute flash exposure to match the ambient light via a sensor on the flash unit, or through the camera lens (TTL). Non-TTL units should be set manually to provide light that is slightly less than the back light so subjects have proper detail. To determine exposure, aim the camera meter or a separate meter at a bright sunlit subject. For example, if the indicated exposure is $1/125$ second at f/11, set the manual flash between f/11 and f/16. When there is time, try several f-stops. Read flash and camera instruction booklets for details.

COLOR AND FILTERS

With color negative film you'll have little need for filters, which is fortunate because makers of point & shoot cameras don't include a way to attach a filter in front of the lens, though Cokin filter holders are available. Users of SLR cameras screw filters into the front of a lens, or use a separate filter holder with slide-in filters, but again, with print films filters are almost superfluous. If you do use a filter that affects color with negative films, make a note to the processor about what you did to avoid printing "corrections" you didn't want.

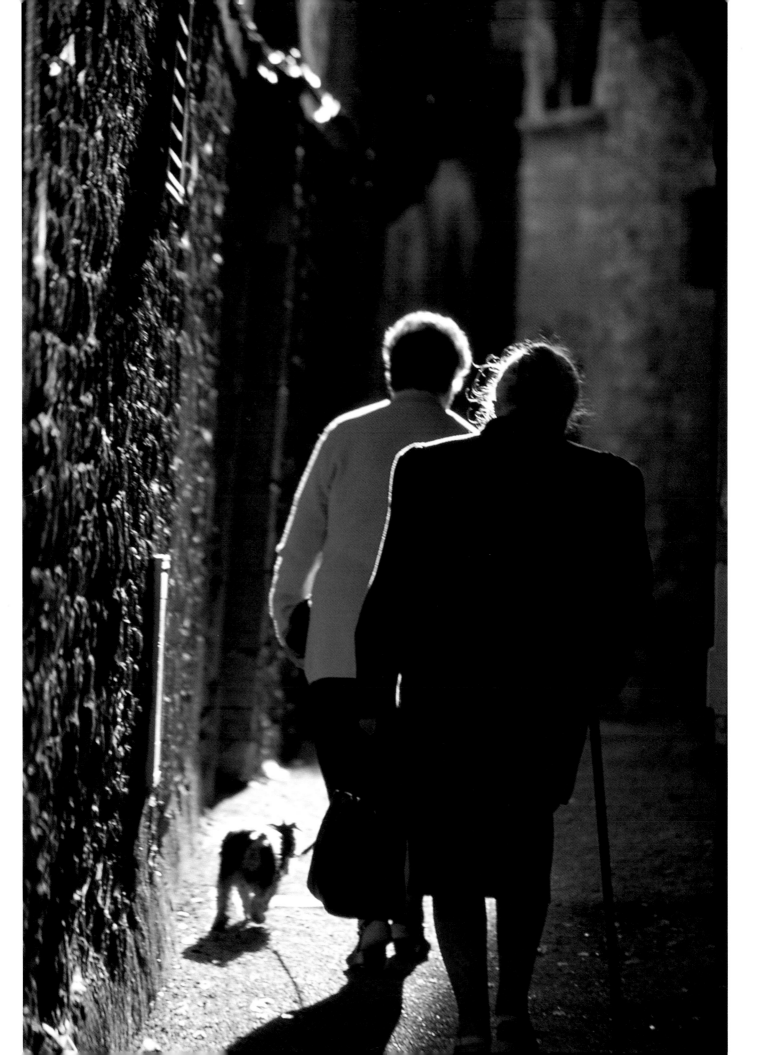

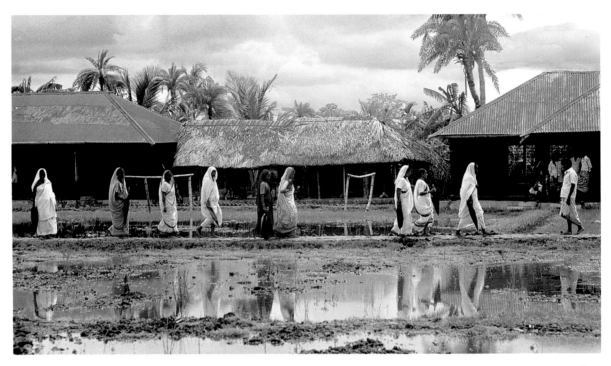

Above: This lovely photograph by Lydia Clarke Heston was taken in the village of Dacope, Bangladesh after seasonal torrential rains and resulting floods. The pattern of women was exciting and she caught them with a 105mm lens and a 1A warming filter on a Canon SLR. Lydia's husband, Charlton Heston, was there working on a motion picture for an organization that helps people after disasters. The picture was made on slide film that Lydia scanned into her computer and printed after a bit of image tweaking. The soft light of faint sun filtered by thin clouds is elegant. **Opposite:** Side light outdoors shows form here as it does indoors (described in chapter 4), except that the sun is an enormous light source you can't move. Wait for the sun to shift as it did on a September afternoon to emphasize details of the classic façade of Chartres Cathedral in France. The amazing builders of ancient cathedrals often faced the main façades to the south where the sun would delineate Gothic sculpture and pour through stained glass windows. A stock agency accepted this, taken with an SLR and 28mm lens on Ektachrome 100VS.

Basic Filters. Slide film users can employ a skylight 1A or 1B filter or UV filter on a lens full time. Any of these filters will protect the lens, and the skylight 1A warms a subject slightly, useful on cloudy days. For greater warming try an 85C or Tiffen 812 filter. A neutral-density filter reduces film speed by half or more, depending on its number, and is handy for multiple exposures or when you need to use slow shutter speeds in bright light. A polarizer filter reduces reflections on water or glass, and darkens blue sky. For more advice about shooting color negatives with floodlights talk to the operator of a one-hour lab.

Filters for Special Effects. For slide film users, there are a few filters available that produce great effects. A star filter makes light sources flare decoratively. A fog filter creates a hazy effect, lowering contrast and sharpness.

Various colored filters meant for black & white films will tint color films red, blue, yellow, orange or green. The Tiffen Company offers an informative color brochure about their filters. See the resource section on page 122.

THINGS TO WATCH OUT FOR

I received the list below from a stock agency when they returned some of my pictures they felt were no longer leasable, which is done at least once a year. They told me, "Since it's impossible to provide an explanation for each image returned, the following list gives you the criteria we use to edit your work." Some of these guidelines may be helpful to you.

- Lack of sharpness due to camera shake, slow shutter speed, or faulty focus
- Over- or underexposure
- Confused composition
- Distorted color balance caused by mixed light sources
- Awkward moments: expressions, gestures and action
- Competitive (messy) backgrounds
- Poor lighting, too much contrast or flat light

PHOTO PROJECT

Look in magazines and newspapers for a variety of pictures taken in assorted daylight situations. Try to find examples of close-ups, artistic clouds, beach scenes, athletic events, street scenes, distinguished buildings, busy markets and whatever else you would like to do yourself. You'll find some excellent examples in *Popular Photography*.

Clip the pictures you admire and Scotch™ tape them onto blank 8½x11 pages. Write a few sentences to explain—to yourself—why you feel each example is outstanding.

Take your outdoor inspirational images along when you travel or explore nearby home. They should help you be alert for similar situations. As an example, I clipped an unusual shot of shaded water lilies, almost colorless in the foreground, with red cloud reflections on the water in the top third of the picture. I may never find as good a situation, but I hope I'll be a more thorough explorer.

Frank Peele crawled through this sandstone formation on Navajo land in Antelope Canyon near Page, AZ. His reward was incredible variations of back light and color that vary continuously during the day, and differ according to season. Frank shot with a Mamiya RZ67, a 50mm lens, and Kodak Pro negative film. The first time I saw an Antelope Canyon photograph, I was sure it was computer generated, but it's nature's etching of sandstone layers as seen in what the Navajos call "Sacred Light."

LIGHTING EQUIPMENT (BRIEFLY!)

WHO NEEDS FLOODS AND FLASH?

DO YOU IMPROVISE A PHOTO STUDIO AT HOME USING HOT LIGHTS (TUNGSTEN), FLASH OR DAYLIGHT COMING THROUGH WINDOWS?

Maybe you reflect or diffuse lights to brighten shadows, and hang a background for portraits. If lighting pictures indoors seems laborious, you may take most of your portraits or still life setups in sun or shade. Daylight is beautiful expedient light, but in cold or rainy weather outdoor photography is uncomfortable and a home studio can be handy, as it is at night, too.

USING ARTIFICIAL LIGHT

Lights you can control give you basic experience in lighting techniques. It's enlightening (no pun intended) to shoot with artificial light, which includes floodlights, also called hot lights, and electronic flash, also called strobes. Flash in the camera or on top of it is quick and convenient, but is pictorially ordinary. In this chapter I'll discuss a variety of

equipment mainly for indoor shooting using techniques for what I call *applied lighting*. If you haven't photographed in a studio, knowing more about equipment could motivate you to give it a try. Artificial light

A decorative blue and gold macaw photographed on its perch in a Marriott hotel lobby in Palm Desert, CA. I used a 28–135mm Canon zoom on a Canon SLR. With the lens at 135mm and a fortunate black background I shot using a Canon 380EX dedicated TTL flash without having to calculate exposure, which was done electronically. The film was Ektachrome 100VS, which often isn't fast enough in low light levels, but is very accurate with flash. This could easily have been taken with a point & shoot camera.

should be part of most photographers' repertoire.

I will point out moderately priced equipment because I'm economical by habit, though I will cover a wider range. Accessories are also described so you are aware of what's available.

Flash Power. Electronic flash is everyone's portable light source, especially when existing light is too dim for handheld exposures. Most familiar is flash in the camera, or portable units mounted on a single lens reflex. Built-in point & shoot and SLR flash has limited power, but it's handy to brighten shadows, called flash fill, when subjects are close enough. Most separate portable flash units, made in various sizes, offer more light and versatility than on-board flash. Studio flash units are larger and more powerful than smaller portable units, and they cover wider areas and longer distances. When they are diffused they are strong enough to work at smaller lens apertures.

Flash Power Designations. The light output of electronic flash units is described in watt-seconds (WS). In-camera units, rated at 50–85WS, are powered by the camera battery. Portable units include batteries and are rated up to about 200WS. Large handle-mounted models, nicknamed "potato mashers," are favored by wedding photographers for their greater light output and fast recycling. News and wedding photographers often carry additional battery power packs for faster recycling and more flashes. Studio flash units operate either on A/C from separate power packs that are self-contained, or may be plugged directly into A/C. They range from 160WS to around 5,000WS. Prices rise along with power output.

Note: Flash manufacturers rate their own units, and not all 100WS units, for example, are equal in power. Differences may be small, but it's wise to test new portable flash equipment by using guide numbers, as follows.

Guide Numbers. Manufacturers assign guide numbers (GN) to their portable units, stated for ISO 100 film. For a test, don't choose a room with white walls and ceiling because bouncing light will boost guide numbers above average. To test a flash unit, photograph a subject from ten feet at an f-stop suggested by the unit's guide number. Divide the guide number by ten, or whatever the distance in feet from flash to subject, to find the f-stop. As an example, a GN of 80 divided by ten feet indicates f/8. The higher the guide number for a given ISO, the more powerful the unit. Guide numbers are explained in instruction booklets packed with flash units.

For cameras with built-in flash, memorize the close and far limits for the flash given in instruction booklets. The aperture for flash exposure varies according to flash power, film speed, distance to subject and subject brightness. If flash range is three to fifteen feet, depending on lens focal length, it means don't use flash closer than three feet and don't expect the flash to be effective beyond fifteen feet from a subject.

Recycle Time. This applies to all flash units and refers to the time required after a flash is fired for the unit to build up another electrical charge, that is, to recycle. Flash readiness is shown by an indicator light that comes on. The closer you are to a subject, the less energy a unit needs to flash, and the faster the recycle time. When batteries are fresh, less time is required between flashes. If batteries are low in a portable unit, and recycle time gets too long, you can move indoors and plug the A/C adapter into an outlet to save the batteries. Remember to carry a fresh set of batteries when you plan to shoot a lot of pictures at a wedding or party. You'll know batteries are low when recycle time is annoyingly slow. Recycle time is uniform when a unit is A/C powered.

Flash Duration. Portable units and those built into cameras flash at about $\frac{1}{1000}$ second. Studio units flash at $\frac{1}{500}$ second to $\frac{1}{1000}$ second and faster. In the dark, the operative exposure speed is that of the flash. In daylight indoors or out, the flash interval is still $\frac{1}{1000}$ second, but a shutter speed like $\frac{1}{125}$ second may allow

Babies and young children are natural subjects for bounced flash. The light doesn't irritate their eyes or dispositions, and bounced light does not create harsh shadows. This was taken with a now-outmoded Konica F-1 SLR and my old faithful Vivitar 283 portable flash pointed at a white ceiling. The film was Kodachrome 64, and the flash sensor determined exposure for the f-stop I chose. When you bounce flash in rooms that are not white, or pastel, shoot at several f-stops for safety's sake.

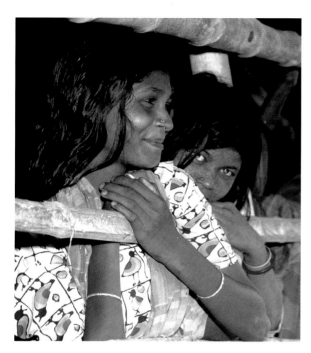

Lydia Clarke Heston visited Bangladesh in the 1980s when her husband, Charlton, was narrating a movie for an American charitable organization. One day when Lydia was on her own with a guide, she met these Bengali women standing in their rice-winnowing shed. Quickly, she adjusted a portable flash on her Leicaflex SLR and made some slides—one of which she scanned and printed. Any SLR or point & shoot camera with built-in flash might have made a similar image because the distance from flash to subjects was only about five feet.

both ambient light and flash to be exposed according to methods described below. Try setting a $\frac{1}{2}$ second exposure with flash in a normally lit room with people dancing or moving, and you could get interesting ghost images from the ambient lighting.

Portable Flash Units. Two exposure methods are used by portable flash units.

Through-the-Lens (TTL) Exposure. The term "dedicated flash unit" refers to a flash unit that is designed for through-the-lens

exposure. An electronic sensor at the camera film plane meters the light coming through the lens, and in a hard-to-imagine mini-fraction of a second, adjusts the flash duration for ambient light and flash based on film speed, subject reflectivity and distance. The flash tube zooms automatically in more expensive portables to match the zoom lens focal length. Dedicated flash units are made by camera manufacturers for their cameras, and by independent companies for a variety of camera brands.

Through-the-lens flash exposure simplifies photography with its in-camera calculations, and there's more time to concentrate on action and composition. When a dedicated flash balances light output with ambient light, the background is often detailed rather than dark, and you get a more pleasant picture than you might with a non-TTL unit. A prime example is when an indoor photo includes the view through a background window; flash on the main subject is computed along with exposure for the outdoor scene.

Non-Dedicated Unit Exposure. You set the film speed on a flash dial, which indicates f-stops to use for a range of distances. The unit senses the light reflected back from a subject and adjusts flash power for proper exposure at the lens aperture you set. I've found the exposure accuracy of my vintage non-dedicated Vivitar 283 is consistent, and other companies such as Sunpak make equivalent units.

Costs of portable flash units range from under $100 to over $500. There are many brands and models available to suit your needs and budget. The least expensive may not have all the features you want, but the most expen-

sive probably has more features than you can use. Check photo supply stores, read advertising in photo magazines, request brochures and check catalogs where various units are described.

HOME STUDIO FLASH EQUIPMENT

Monoflash. This studio equipment is ideal for those who do not have large work areas.

Greg Lewis is a tenured professor of photography at California State University at Fresno who teaches lighting, photojournalism, business principles and related subjects. At Christmas, my wife and I look forward to Greg's varying family photographs, of which this is an example. Against a dark background he set two monoflash units, bounced one into an umbrella at left and another into an umbrella at right, which is not quite as close. High on the rear right was a portable flash, used as an accent hair light. He used color negative film in a medium format camera.

Popular monoflash (or monopack) units are self-contained, each with its own built-in power supply and modeling light. They are available in various power ratings such as 200WS, 300WS, 500WS or more, and two of them can be a practical investment. Even when a monoflash is diffused in a light box or reflected from an umbrella, it usually offers enough light to shoot at practical apertures.

Monopack units are relatively affordable. I have seen a 150WS A/C unit (guide number of 135 with ISO 100 film) advertised in early 2002 for $165, and another 320WS unit (guide number 320) priced at $278. Inquire about similar versatile studio units and price them at your local photographic supply store. Two monopacks would be a neat way to begin outfitting a home studio, especially when combined with an umbrella reflector and/or a softbox.

Separate studio flash heads and power packs, described below, are a more expensive alternative, depending on brand and power.

Umbrella Reflectors. These open like umbrellas and are convenient light-softeners in home-based studios. Reflector umbrellas are made in several sizes up to six feet wide, either square or round. Those lined with white material create softer shadows than those lined with silvered material. Gold-tinted lining is also available for warm-toned light. Special clamps are designed to fasten the stem of an umbrella to a light stand. Folded umbrellas are easily portable.

A softbox is a box-shaped diffuser-reflector that produces soft-edged shadows. When softboxes or umbrellas soften a light source the light output is reduced, perhaps by one-half

Advertising and celebrity photographer Charles William Bush lent me this marvelously lit picture, which he shot for a health insurance company. The theme was "family," and he assembled these models in front of a tan background. Charles used Dyna-lite studio flash, Chimera softboxes, and Kodak EPP (print film) in a Mamiya RZ67 with a 150mm lens and an 81A warming filter. This example of elegant studio lighting was part of a series for print and billboard ads.

compared to direct flash. Hence, watt seconds in the thousands are favored by some commercial photographers. By comparison, a portable flash with a guide number of 120 has to be fairly close to a subject when it is reflected or diffused. Monopacks may be more distant and cover a larger area.

Lighting Kits. A variety of companies package two or more monoflash units, um-

brellas and/or softboxes, light stands and a case as a kit. While these kits are available in a wide range of price points, expensive kits include more powerful strobes. Many stores also sell umbrellas and light stands separately.

Flash Meter. Guide numbers are not usually used for studio flash units. Instead, a flash meter that electronically reads flash intensity and indicates the correct f-stop is the instru-

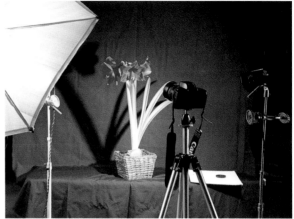

Left: This red lion amaryllis was photographed with a 28–80mm Canon lens, using an 80A filter to cool quartz lights, on a Canon A2. That lens will focus about eighteen inches from a subject. I often shoot still lifes with hot lights because I like seeing tonal subtleties before shooting, and my portable flash units include no modeling lights. When I use flash, I may guess how it will look, or I set 150W floods next to the flash for an approximation. The exposure on Kodak Gold 400 film was $^1/_8$ second at f/16. It's difficult to tell whether some still life pictures were made with hot lights or flash. **Right:** Here is the lighting and camera setup for the amaryllis picture. One 600W quartz light was aimed into the umbrella, and another was used directly about four feet away at the right. On the table is a white reflector I used for other shots. The "table" is an ironing board in front of a dark cloth hung on the wall with gaffer's tape. I've made many close-up pictures on the ironing board. It is easily stored and narrower than a card table (on which only the front area is practical for close work). For this I shot with a point & shoot, a 38–105mm lens and Kodak Gold 200 film.

ment of choice. Most flash meters also measure ambient light. You can find a variety of meters listed in distributors' catalogs. The Polaris I use is well designed and costs less than some.

STUDIO FLASH EQUIPMENT

These larger units are powered by A/C, or by portable battery packs. A typical studio flash outfit consists of an A/C power pack into which you can plug several flash heads, each of which shares the total power. Studio flash units include built-in tungsten modeling lights that allow you to preview light placement. Professionals value high-powered flash for these reasons:

- With three or four flash heads a photographer can light a relatively large set. It's not unusual for a studio photographer to need four power packs and numerous flash heads to light an interior or a group of people. To avoid a studio floor full of light cords, professionals may use remote controls to fire flash units fitted with slave sensors. (There are remotes available for mono-packs, too.)

- Several studio flash heads may be diffused in a softbox six feet wide or larger with white translucent material across the front of the box to produce a broad even

light popular for groups or large products.

Powerful studio units and softboxes are important to big league advertising photographers who may charge $5,000 a day and up for their special skills, reputations, crews, studios and equipment.

For more about all categories of flash equipment, request folders from the manufacturers listed in the resources section of this book.

HOT LIGHTS

Tungsten photo lights get very hot—hence their nickname. Hot lights are relatively dim compared to most popular electronic flash units, but they offer the advantage of continuous lighting on the subject before you shoot. Hot lights can be masked with barn doors (see below) or diffused in umbrella reflectors. Photoflood and quartz bulbs are rated at 250W, 500W and 600W. Here are the main hot light choices.

An aluminum reflector into which you screw a photoflood bulb is a basic option. Reflectors, made in several diameters with socket and wire included, are convenient and inexpensive. Mounted on light stands, reflectors can be aimed at a subject or into an umbrella that reduces light intensity to about half. That's okay for still lifes or portraits—except of children, who can't sit still, so strobe is advised. Brighter light is possible by directing two photoflood lights into an umbrella. Bulbs are available in 3200K and 3400K ratings, but the 3200K lasts longer.

An alternative is a 3200K reflector flood bulb with its own reflective coating. The bulbs

cost $16 each when I last bought them, but they last quite a while. These require a socket with an off-on switch, fifteen to twenty feet of wire, and a wood or plastic handle to manipulate the light. Reflector floods and sockets pack into a smaller space than aluminum reflectors. In a large shoulder bag I carry two wired sockets that I assembled with clamps, plus two quartz lights with cords, and extension cords. Reflector bulbs are packed separately. Keep in mind that when hot lights are fairly close they may make some portrait sitters uncomfortable.

Quartz lights in compact reflectors are rated at 600W and 3200K. They're compact and recommended, but more expensive than a reflector with flood bulb. Quartz units include switches and wire and can be mounted on light stands. Their bulbs are replaceable and last at least as long as a photoflood or reflector flood.

Blue photoflood bulbs are available, rated at 4800K, which makes them warmer than daylight color films. A 500W blue bulb rated at eight hours can be had for a low price. When you don't want to use flash they could be helpful for hot light fill outdoors, or indoors when daylight is dominant.

LIGHTING ACCESSORIES

Here is a list of accessories and gadgets, some of which you may consider useful.

- Spotlights are used as hot lights for still lifes, as portrait accents or to dramatically illuminate part of a set or room. Their special bulbs are housed in a focusing reflector with a fresnel lens

(glass with concentric grooves) to help soften the light. I own two 500W spots, but rarely use them because diffused floodlights are softer.

- Barn doors attached to a spotlight (or flood reflector) are metal masks that can be adjusted to widen or narrow the light beam.
- Remote slaves provide wireless connections between electronic flash units. When lights are distanced from the camera, it's a pleasure to pop them all from the camera via a handheld control unit. Wireless control is relatively

expensive and is made by several companies including Wein, PocketWizard and White Lightning.

- Remote flash triggers are attached to portable flash units that fire in synch with the main or camera flash. Flash

Left: Everything displayed in this shop is soap, made in dozens of shapes and sizes to resemble items such as candy, a calculator and small toys. This image was taken for a magazine story. It was lit with daylight, which was available through a large window. To softly brighten shadows, at left and right I added two portable flash units directed into two three-foot umbrellas, each clamped to light stands. An SLR on a tripod and a 28mm lens were used with Ektachrome 64. **Right:** Ken Whitmore made this simple setup for prospective stock his agency could sell as a magazine or ad illustration. It was planned as part of a series on setting a table. Highly reflective materials need to be photographed in a "tent," which is an enclosure that reflects softly on materials like silver. Ken's SLR lens was positioned (on a tripod) through a hole in the tent top. The film was Kodachrome, and the lighting outside the tent was portable electronic flash. Tents will be discussed in detail in chapter 7.

triggers adapt to portables only, take the place of wiring units together, and are much less expensive than radio control units.

- Clamps are made in various shapes and sizes, and can be used for fastening an umbrella to a light stand, clamping a light to a shelf, mounting a portable flash out of camera range or to attach an electric socket and handle combination to a light stand. I've been using a heavy duty clamp similar to one that Smith Victor Gaffer Grip offers. It has notched claws that fasten well to light stands.

- Diffusers are usually circular and clamp onto hot light reflectors. White plastic types mount snugly onto portable flash heads to soften the light.

- Light stands and hot light systems are made by Lowell, Smith-Victor, Arri, SP Studio Systems and others. Light stands are usually made of aluminum, and extend from about four feet to eight feet and higher. The tallest models are also heavier, and a six-footer is enough for many photo situations. Check local photo supply stores and catalogs from equipment manufacturers.

- Umbrellas and softboxes are available from companies such as Chimera, Photoflex, Photek, Westcott and Calumet, as well as from local photo supply shops and catalogs.

- Cases for lights, stands and accessories are included with kits, and separately, from photo supply stores.

PHOTO PROJECT

Shoot progressive pictures showing how something is made or done. Choose a subject that's easy to access. As a suggestion, photograph someone making a pie, cake, soup, etc. The sequence should follow a process in steps that explain how it's done. Whatever you choose to shoot, your challenge is in lighting each situation. Two hot lights or flash units, placed on stands, should do it. Add another light for the background or as an accent if you wish. Reflected or diffused light should provide pleasant results, but direct light is brighter and permits faster shutter speeds. I suggest using a tripod for precise close-up compositions and greater depth of field at smaller apertures.

For handheld exposures I recommend film rated at 200 for non-diffused lights, or 400 for diffused lights. Have enlargements made for yourself and your model(s). Study the lighting. Are the shadows too large or dark? Would viewers understand the steps you shot from different camera angles? Without captions? If my suggested subjects don't inspire you, consider using a youngster assembling a model or building with Legos®. The photography shouldn't take so long that the subjects are tired. If you are not pleased with the lighting or the subject, reshooting the series will be worthwhile.

INDOOR LIGHTING

MAN-MADE ARTIFICIAL LIGHT IS ESSENTIAL TO TAKING PICTURES EVERYWHERE.

We use flash to brighten shadows; besides flash built into cameras, separate flash units produce much brighter light. Our alternative to flash is *hot lights,* the term for tungsten and quartz light sources that heat up in use. It's nice to preview how subjects will look with hot lights and then adjust the lights accordingly. Many A/C powered flash units include a built-in tungsten modeling light to help place the flash. The versatile photographer is familiar with each type of lighting. Guidance about hot lights and flash follows.

PORTRAIT LIGHTING

Flash Options. Informal portraits may be taken near windows, or with flash or hot lights. Flash promises sharp images, but flash in or on the camera is flat and puts dark shadows behind people. A second flash at one side

as bounced flash. Keep in mind that some ceilings are too dark for efficient bounce.

Backgrounds. In addition to asking a portrait sitter to wear clothing that's not too patterned, you need to choose an appropriate background. A plain wall or movable screen, or a plain or lightly textured sheet or blanket, or photographic background paper may be suitable. Rolls of background paper are made five (half width) and ten feet wide, and a suitable length can be cut from the roll and taped to a wall. A role of paper may also be hung from a pole suspended horizontally between two metal poles that are spring-jammed against an eight-foot ceiling. Ask at photo supply stores about equipment to hang backgrounds. For a mind-boggling array of photographic backgrounds, ask Denny Mfg. Co. for its catalog. They're listed in the resources section.

Placing Lights. Have your portrait subject sit on a stool or chair with a back that doesn't show. Place hot lights or flash at distances and directions that make the sitter look good. A sensible start is a light slightly higher than the sitter's head at a front 45-degree angle. This is called the main or key light and may be direct or reflected. On the other side of the sitter's face, reflect a fill light from an umbrella or a softbox to brighten shadows. Adjust the fill until shadows are as bright as you wish. If you have a third light, aim it at the background behind the person's head to create a contrast. That light should be a lower wattage so the background has some tone. A fourth light, also weaker than the main 45-degree light, may be aimed about 45 degrees from behind to glance off the person's hair and cheek. It's

What type of lighting was used here? It may have been daylight from a window on the left, or hot lights pointed into an umbrella, though they might have been uncomfortable for the model. Actually, I shot with studio flash diffused in an elevated softbox at the right, simulating a window. It was taken in a friend's studio where I borrowed his 400WS monoflash units and his glassware props. I was shooting prospective magazine covers with an SLR and Kodachrome 64 film. I also borrowed my friend's flash meter, but now have my own.

of the subject (activated by a photo eye) helps to soften shadows, gives faces more depth and often lights the background. Reflected or diffused flash is more friendly to people because it's softer or smoother. When it's atop an SLR aimed at a light-colored ceiling it's referred to

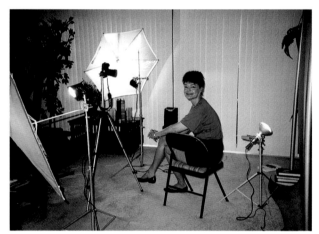

Top Left: The first of three portrait lighting variations. The background was a roll of blue paper, the background light was a 100W reflector flood bulb and the illumination was two 600W quartz lights reflected from white umbrellas. The light at the right of the model was closer than the fill light at the left. On a tripod was my Canon A2 SLR with 28–80mm Canon lens and 80B filter to correct the color temperature for Kodak Max 200 print film. Exposure for all portraits was $^1/_8$ second or $^1/_{20}$ second at f/11 or f/8. **Top Center:** The light at the right was in the same position as in the first example, but the fill light was farther away, resulting in a darker shadow side. The effect is a little stronger, but still pleasing. **Top Right:** The lights at left and right were higher than in the first two examples. We shot many poses and lighting variations in a living room studio. This shows the model in a slightly different mood. These portraits could have been taken with flash, but the monolights I often borrow were not available. Tungsten lights worked well, and because I informed the processor about the 80B filter, print colors were right on. **Bottom**: A shot using flash on the camera shows a relatively simple configuration of lights. The model is a bit farther from the background than she was during the portrait session. At the right are poles that expand against the ceiling to hold the background paper roll.

a rim light, a type of back light and often a neat accent. Sometimes rim light may reflect on the subject from the background light.

Maneuver hot lights, flash, umbrellas and softboxes on stands to flatter the sitter. Instead of an umbrella, an assistant can hold a white illustration board or other reflector in various places until you see what you like. For flash units without separate modeling lights, close to the flash place separate 75W or 100W bulbs in reflectors to preview what the flash will do. Alter the lighting and poses as you go along. Variations are expected at a portrait sitting. Remember to use a filter with hot lights and daylight print or slide films. The 80B is good with negative films, and the 80A with slide films but results with each are close. Compare for yourself. With a point & shoot camera, rig or buy a filter holder, but test first without a filter, advising the processor about the light source.

Keep in mind that film is cheap in relation to the time invested. Experiment with portrait lighting to learn valuable techniques that are applicable to other subjects. Be prepared to toss out pictures that you or the portrait subject don't like. For more information on portrait photography, see *Portrait Photographer's Handbook* by Bill Hurter (Amherst Media).

STILL-LIFE AND CLOSE-UP LIGHTING

Expect to make additional lighting discoveries by photographing still lifes indoors. It's easy to arrange objects on a horizontal sheet of colored paper that curves up against a wall so there's no horizon line behind the subject. That's a favorite way to take still life pictures, but approach the challenge on whatever type

Ken Whitmore devised a symbolic setup of mask, background and writing tools for an annual report. In his home studio, using a single studio strobe and an umbrella, Ken worked with a Nikon SLR on a tripod and Ektachrome 100 film. He tried other lighting arrangements, but preferred the side light for added impact.

Left: The ring and pendant were photographed in an improvised tent. A sheet of heavy white paper was fastened to the wall behind and arched over the pieces, held in place by an assistant. One 100WS flash unit on a stand was aimed at the reflector, and exposure was measured with a flash meter. I used a 50mm macro lens on an SLR and Ektachrome 100 film. **Right:** Be prepared to shift lights to get the effect you like. The lower half of the cuckoo clock was done with soft umbrella-reflected floodlight.

of background you like, such as textured fabric, patterned paper or a piece of carpet. Experiment with subject matter and backgrounds, and take chances with lighting. If you fear that you may not remember where you placed lights and other equipment, make notes as a guide or snap pictures of your setups for future reference.

For close still life shots, you'll achieve better depth of field using small apertures and slow shutter speeds, such as one second or ½ second. Work from a tripod for precision and comfort. Hot lights are ideal and when subtle lighting changes are needed, and photofloods or quartz lights let you quickly view variations. Good still life photography depends on attractive composition and shadow control, so position main and fill lights carefully. Try both direct and reflected lighting for mood, clarity and pictorial impact.

Reflective Subjects. When a subject is reflective, such as glass or metal objects, use a "tent." This refers to a white reflective enclosure in which you arrange your still life and place lights to bounce against, or shine through, a diffusing material. A tent requires an armature, or basic structure on which to place the cloth. Commercially made tents are available. Check ads in photography magazines, photo supply stores and equipment catalogs.

Reflected Light. When it fits the subject, I prefer to use reflected light on small subjects like jewelry or cameras and lenses. Some close-ups require a macro lens on an SLR. I may make a composition in direct light first, using floodlights, and then I switch to full or partial reflected light. That's the way the pendant and ring were photographed. Be prepared to shift lights to get the effect you like. The lower half of the cuckoo clock was done with soft umbrella-reflected floodlight.

A Glass Base. Another studio still life technique is to place objects on a sheet of glass, the

Above: Tammy Hoya, a professional specializing in children, says, "This image is special to me because it was my first Kodak Gallery award. I took it for a Christmas card and the child was coloring forms I drew on paper. The stained background doors were found in a barn on property we bought. Light came from a north-facing window in my studio." Tammy used ISO 400 negative film in a Mamiya RZ with 180mm lens.

edges of which rest on supports—like stacks of books. Beneath the glass is background paper curved up a wall or backing to be seamless. With the camera above the subject and the background below lit, a subject on glass appears to float because there is neither horizon line nor shadows when it's done right. Place hot lights far enough from the glass to avoid damaging it, and avoid reflections.

Flash for Still Life. Studio photographers may use electronic flash for still life because their large units pop enough light to work at small apertures such as f/22 for good depth of field, often with medium format cameras and ISO 100 film. If you try flash for the experience, small portable units a few feet from a subject will put out enough light, maybe even when reflected. Make test shots and keep notes about light-to-subject distances and f-stops. The auto-exposure capability of portable units ought to adapt to still life without your needing a flash meter.

By Daylight. Lots of still lifes and portraits are photographed indoors in daylight near a window or glass door. Use reflectors to fill shadows. If daylight isn't bright enough, try using electronic flash as the key light. Because it's the same color as daylight, light from a door or window can serve as the fill light. As a test, reflect hot light into shadows made by daylight. The color will be warmer than with flash, but warm is beautiful and certainly popular.

STUDIO PORTRAITURE

Portrait and commercial studios use electronic flash for most portraits because there's no worry about subject movement. Their flash equipment remains set up between shooting jobs, and the flash may be configured in a similar way for various portraits. Portrait photographers are familiar with most exposure settings for their lights, and small differences in light-to-subject distance aren't critical with color negative film. Studios use flash units plugged into a power pack or monolights with self-contained power. Flash output such as 500WS is common, because half the light is dissipated when aimed into an umbrella or softbox.

Backgrounds. All sorts of background colors and patterns are available for portrait backgrounds (see resource section), including landscape paintings. You can also devise your own backgrounds from materials found in a fabric shop. Either roll the background down from a rod fastened to poles or attach it to a wall. Background fabric may also be mounted on a frame on casters with a different color or pattern on each side. Frames can be stored when not needed. Choose backgrounds that give portraits more charm.

PORTRAIT CASE HISTORY

The lovely image of a bride holding flowers looks like it was taken with flash, though it was shot indoors with daylight. This portrait was chosen for the cover of the March 2001 *Rangefinder* in which photographer Monte Zucker described his high key daylight technique. Zucker is widely known as a wedding and portrait photographer. He has taught countless seminars on photography and lighting. Here's his how-to description:

"This portrait is an example of my new approach to high key portraits by window

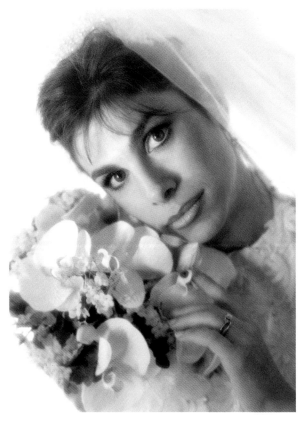

An ideal photographic magazine cover by Monte Zucker. This image was featured on *Rangefinder* magazine's March 2001 issue. Details of how he lit it are in the text.

light. Strong, direct sunlight was coming through a large window in the front of a studio where I was holding a class. I blocked the view of the window by leaning a Westcott translucent panel behind the bride, turning the sunlight into a soft 'north light' type of lighting. Light from above the panel served as a built-to-order hair light.

"I used a Westcott Monte Illuminator (silver reflector on one side/black on the reverse side) on a stand to pick up some of the light coming through the panel, using it as the main light to illuminate her face. The small size of the reflector allowed me to direct the light

into her face, just as if I were using a spotlight. The falloff of light toward her hands was visible to the eye before even making the exposure. When I noticed that the shadow side of her face was too dark, I placed another reflector camera-right to open up the shadows. The light coming from both sides of the translucent panel created soft highlights on both sides of her face.

"The final touches of the image were done in Photoshop. These consisted mainly of softening the photograph with Gaussian Blur at a 20 percent density. I then completely erased the blur from her eyes, the bridge of her nose and her mouth. I added more blur to the sides, increasing it as I got out toward the edges of the portrait. This created the effect of a wide open lens with an extremely short focused area. The high key concept works as well outdoors as it does indoors." Monte used a Hasselblad 203FE camera and negative color film.

Fantasy. Let's discuss lighting a portrait similar to Monte's with electronic flash or quartz lights instead of daylight. The main light would be at the left in a softbox or reflected from an umbrella slightly below face level. The nose shadow and highlights in her eyes indicate the light's angle. The softbox or umbrella could be partly masked (with pieces of illustration board) or placed to be brighter on the girl's face than her hands. Another diffused strobe or hot light at right would provide weaker fill light. Behind the model would be a brightly illuminated white background. If you don't have access to computer retouching, consider using a soft-focus portrait lens or a diffusing filter in front of your regular lens to achieve a similar dreamy, beautiful feeling.

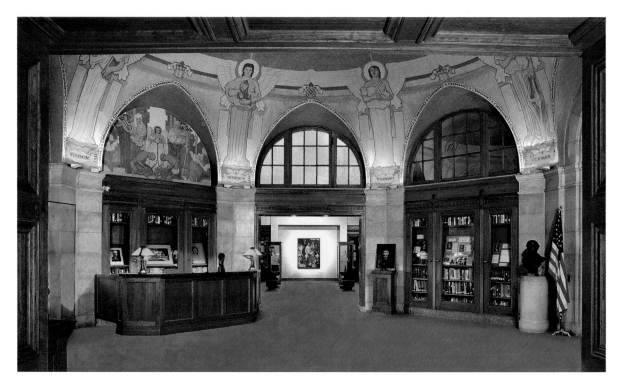

Above: Frank Peele demonstrated excellent technical skills photographing the Abraham Lincoln Memorial Shrine in Redlands, CA, which houses a large collection of Lincoln and Civil War materials. To make use of existing tungsten lighting, Frank used just the modeling lights of multiple studio strobes plus quartz halogen lamps to evenly illuminate the library. He made multi-second exposures with a Mamiya RZ camera and Kodak negative color film. In chapter 9, you'll find Frank's beautiful exterior view of the library. **Bottom Left:** To photograph an artist and some of his work in a gallery that had white walls and ceiling, I pointed the head of my Canon flash at the ceiling for even lighting and no dark shadow behind the subject. The Canon A2 and TTL flash calculated correct exposure. Practice bounce and record the f-stops for reference. **Bottom Right:** Smooth electronic flash brightened a happy wedding party, photographed by Jeff Schmitt of Seattle. To illuminate bride and groom, Pam and Jeff Eidukas and their parents, Jeff used two 1100WS strobes bounced against a white ceiling and walls. His camera was a Mamiya 645 on a tripod, and he shot with ISO 400 negative color film. The indoor exposure was balanced for the outdoor light.

MORE INDOOR LIGHTING VARIATIONS

Hot Lights. In chapter 6, I described the characteristics of hot lights for home studio use. To learn lighting techniques more quickly, work with at least three quartz or photoflood lights. You may need two hot lights reflected into an umbrella to be bright enough at three or four feet from a subject to make suitable exposures with ISO 200 film and the camera on a tripod. A third light, diffused by another umbrella, could brighten the shadow area. A fourth light on the background completes a typical home setup.

With an 80A (for slides) or 80B filter (for negatives) over an SLR camera lens, or a point & shoot camera lens, the color temperature of tungsten light will be corrected to match daylight films, as seen in the photos on page 82. Advise negative film processors about the filter used so printers can make adjustments. No filter is needed if you use tungsten balanced slide film, such as Ektachrome 160T. Prints from slides can be excellent, though somewhat more expensive than prints from negatives.

Electronic Flash. With enough flash power, follow the lighting configurations recommended above for hot lights. One or two flash units with guide numbers of 100 or higher, reflected into an umbrella with ISO 200 or 400 film, should be enough light, five feet or closer to the subject. Since portable flash power varies, shoot tests with one or two units pointing into an umbrella at several distances from the subject. Keep distance and exposure notes unless you have a flash meter. The flash in your camera can set off off-camera flash units with slave eyes attached. If necessary, diffuse the camera flash with translucent plastic to be weaker than the umbrella-based flash.

Monolights. Studio-type monolights, self-contained units rated at 150WS to 200WS or stronger, are ideal for home studio use. They offer more light than most portable units and do well with umbrellas or softboxes. Many monolights include built-in slave eyes (for

DETERMINING PREMEASURED LIGHTING DISTANCES

Years ago I visited the studio of a photographer who had shot dozens of magazine covers. He demonstrated lighting a head & shoulders portrait, placing two softboxes to eliminate shadows almost entirely from a subject's face. Each softbox contained a 1000WS flash unit (or two units in a larger box for group portraits). He chose from a series of background colors on large frames that rolled to the set from storage.

He showed me a trick for determining premeasured lighting distances that has stuck with me. Each of his large direct or diffused strobes had a durable string attached to the light stand. At one-foot intervals, starting at about six feet there were black and red marks on the string. He used one slide film consistently, so he could place a light, stretch the string from light to subject, and see its distance quickly. In his memory each measurement translated into an f-stop. Two black lines and a red one might be f/11, etc. He could see lighting effects via modeling lights. His was a lighting formula that varied only slightly according to the gender and color of the subject. I've tried the string trick and recommend it, at least as an experiment.

wireless connection) so one will set off others on stands. These units cost the same or less than pricey portable units made by camera manufacturers. Consider buying at least two monolights as primary sources and fill shadows or brighten backgrounds with smaller portable units.

For battery-powered light consider a handle-mount portable (nicknamed potato masher) such as the Metz 70MZ-5, which has a guide number of 230 (ISO 100 film). These units are versatile but somewhat bulky to hold along with a camera. If you only shoot in a home studio occasionally, compare prices on monolights and smaller portable units, as well as hot light prices. You can buy units rated at 100WS and stay on a budget.

INDOOR AVAILABLE LIGHT

Available light, also called ambient or existing light, is jokingly called "available darkness" when light levels are very low. Photographers

During a visit to Vienna, sports cartoonist Murray Olderman snapped his wife, Nancy, resting in a hotel near a large window. Murray guessed his exposure was a comfortable $\frac{1}{60}$ second using ISO 200 print film in an SLR. "All that warm color attracted me," he explained.

shoot available light picture situations when flash would destroy the mood or prompt people, suddenly aware that a camera is pointed at them, to ask the photographer to leave them alone. Photographs taken in dim or contrasty light are often atmospheric, which helps create authenticity. Decades ago most existing light pictures were shot with black & white because color films were not fast enough. Today ISO 400, 800 and 1600 color films are first rate, so if you are confident with slow shutter speeds and large apertures, you may come up with realistic existing light moments on film.

I've shot numerous pictures in available light when flash or tungsten sources would have spoiled reality. If people noticed, I'd say I was just checking the scene through the finder, which most people accepted because they assumed pictures would be impossible without flash. Available light shooting is indigenous to coverage when authenticity is more important than ideal technique. Situations that call for potentially hard-to-hold shutter speeds include actors or dancers on stage during rehearsals, church interiors or closely-knit lovers. When some blur is inevitable it may create attractive motion patterns. As you may know, stage photography during performances is rarely permitted.

Final Shot. In the past, Kodak lent me a slide that a former staff photographer, Neil Montanus, took of a model by candlelight shot to demonstrate the versatility of an ISO 400 negative film the company was introducing. I didn't save the technical data, but it is obvious a tripod enabled a shutter speed like $\frac{1}{10}$ second or slower. The striking Kodak image inspired me to photograph my four-

Left: Neil Montanus, formerly with Kodak, photographed a lovely model by candlelight to demonstrate the versatility of a new film being introduced by the company. He used an SLR on a tripod and exposed about $1/8$ or $1/10$ second on ISO 400 film. Courtesy of Eastman Kodak Co. **Right:** Inspired by the Montanus candlelit portrait, I shot my own version of my granddaughter Kimberly, described in the text. Each photo has its own mood.

year-old granddaughter, chin on hands, holding very still behind a candle. My elbows were on the counter to steady a Canon 28–135mm image stabilization lens on a Canon A2 body. With ISO 400 Kodak Max (negative) film, I shot at $\frac{1}{10}$ second at f/5.6 at 28mm with the room lights off. Kimberly became my lovely warm-faced model.

PHOTO PROJECT

Arrange a still life where you can use background material that curves up a wall at the back of your miniature "set." Place a card table or ironing board against a wall. Be sure there's room for lights on three sides of the setup. Choose a variety of objects to photograph, in different shapes, some reflective, some bright colored. The objects should be different sizes for a more interesting composition, and if they are surrealistically unrelated, that's fine. People like a puzzle.

Use hot lights or electronic flash. If you want to cheat constructively, make your still life arrangement outdoors in sun or shade, and brighten the shadows with floodlights or flash. Your camera should be on a tripod. The point is to light a still life in at least three different ways. As examples:

1. Use lights directly, though you may reflect one of them.
2. Reflect all lights from umbrellas or with softboxes.
3. Use one light only as cleverly as you can.
4. Back light your subject by placing a light behind it, and use other lights to fill shadows.

THE LIGHT AT NIGHT

PHOTOGRAPHIC OPPORTUNITIES

AT DUSK AND AFTER DARK CAN

BE VISUALLY EXCITING.

SLOW NIGHT EXPOSURES

When I expose at slow shutter speeds using a tripod I always welcome unexpected images and details. As a teenager exploring photography's mysteries and possibilities, I made my first night shots in black & white with an old Rolleiflex on a used tripod. By counting the seconds, I exposed a snowy scene by streetlight. Neither the camera nor I had an exposure meter, though I still have a vintage print from the overexposed negative. Today's color print film is far superior to the black & white I used, and it has excellent latitude to produce good images from night exposures.

Automation. In 1970 I tested my first SLR with a one-second automatic shutter speed at dusk and after dark. I was delighted to be freed from estimating exposures, though for intervals longer than one second I had an exposure

Left: By daylight these fountains are part of a pleasant scene, but at night their color is dramatized against a black background. With my SLR on a tripod I used Kodachrome 200 at a camera-selected exposure I'd guess was ¹/₄ at f/6.3. A longer exposure would have blurred the water more. **Right:** Church displays of votive candles offer subdued light patterns for pictures. I braced myself against an ancient pillar in Spain's Barcelona Cathedral and waited until people were out of the way. Ektachrome 100VS was exposed at about ¹/₈ or ¹/₄ second in a Canon SLR with Canon 28–135mm IS lens. A similar image could have been made with a digital camera, inspected on the viewing screen immediately, and taken again if necessary.

chart for various lighting situations. Now, though many night shots are in the five- to fifteen-second range, SLR cameras offer routine automatic exposures up to thirty seconds. Point & shoot cameras may have automatic shutter speeds from one to four seconds, okay for many night pictures with ISO 400 and 800 films. Cameras that make effortless accurate exposures are part of our night-photography pleasure. Check your camera's slow shutter speeds in the camera's instruction booklet. Remember to turn off the point & shoot flash before you make scenic night exposures.

Digital Automation. In this book I refer only briefly to digital cameras because basic lighting techniques for them are quite similar to those used with conventional point & shoot or SLR models. Most lenses for digitals are built into the camera body. Like film-based point & shoot cameras, when shooting at night or in low light with a digital camera, you are limited to automatic exposures of one or two seconds. Single lens reflex digitals are more versatile and include interchangeable lenses and a range of slow shutter speeds for after-dark shooting. Some also offer features such as exposure compensation (bracketing) and acceptance of an add-on flash more powerful than the built-in flash. More sophisticated digital cameras also cost more, so try not to pay for complexity you don't need.

NIGHT PREREQUISITES

Film Choices. ISO 100 and 200 films are great after dark when your camera exposes in the one- to ten-second range for pictures of

still or moving subjects that blur on film in unexpected, decorative ways. The longer the exposure, the more dramatic blurred lights may become, creating ambiguity such as passing headlights that show as streaks, though cars don't show. I often use ISO 100 slide film for night shots—whether there's movement or not. Cityscapes taken from hills at ten to fifteen seconds are easy for ISO 100 and 200 films. Faster films such as ISO 400, 800 and 1600 are necessary for shutters limited to one or two seconds.

Daylight Balanced Films. Though color films are manufactured to match daylight color there's no need to use a correction filter at night. Lights at night (except fluorescents) photograph more warmly than you see them, but that's usually a pictorial advantage. Warm-toned pictures are welcome. To be sure, make a comparison. Shoot the same night scene with and without an 80A or 80B filter, which convert daylight film to tungsten light sources. If you prefer filtered color, remember that the filter lengthens exposures, so a two-second exposure is extended to four or five seconds, but auto-exposure cameras compute exposure times for you. As for fluorescents and neon lights, distorted color is often decorative after dark.

Flash at Night. Modern flash, in the camera or otherwise, is automated. To include recognizable people or things in the foreground of a night shot, choose a suitable f-stop (a TTL unit will do it for you), and turn on the flash. It will illuminate foreground subjects while a slow shutter speed exposes for night lights. Use a tripod to keep background lights sharp. If the flash pops accidentally for a distant scene, and there's nothing in the foreground, it's no problem because in-camera flash range is only about fifteen feet. On a related note: When you photograph someone

Left: I was able to shoot this gallery opening without a tripod using Kodak ISO 400 print film. As people moved about I exposed three frames, at ¹/₃₀ second and f/5.6. White gallery walls are pleasantly warm because I used no filter to convert the 2900K lighting to daylight-based film, which is made for 5500K daylight. **Right:** It was almost dark when I discovered this elegant flower display. Rather than try a camera-on-tripod slow exposure—no tripod was handy—I photographed it with a Canon TTL flash on a Canon A2. Kodak 200 Max print film did well by the colors. The lighting is similar to what you'd see in direct sun.

or something as a dark silhouette against a bright night background, remember to turn off the flash.

EVALUATING TIME EXPOSURES

Study your prints or slides to discover how well your camera handles night exposures. Machine-made prints tend to make different exposures look somewhat similar, so compare negative densities. While underexposed negatives are pale, properly exposed negatives include both dark areas and clear areas. Overexposed negatives are more opaque. Somewhat underexposed night slides may be okay, but grossly overexposed slides are generally useless. Test shots at various exposures will

Variations of this view of Reno, NV, at night are familiar, but I enjoyed shooting it on a roll of Kodachrome 64 with a Konica 21mm lens on a now-outdated Konica SLR. The automatic exposure was for the lights so cars and people are dark, but flash on the foreground would simply have created an artificial spot.

boost your confidence in using your camera at night.

Older match-needle-exposure SLRs and some compact point & shoot models with shutter speeds no slower than one second may have a "B" setting that lets you expose as long as you depress the shutter release. "B" stands for *bulb,* which is a hangover term from antique lenses operated by a squeeze-bulb release. At a B setting, estimate exposure time based on night testing or charts. Make a series of shots starting at one-half second, and continuing at one second, two seconds, four seconds, eight seconds, ten seconds or longer, depending on brightness of subject and film speed. The more bright lights there are in a scene, the less exposure it needs. Keep notes on night exposures in your camera bag.

ZOOM EXPOSURES

For decades after photography was invented, landscape and portrait painters influenced photographers to emulate them. Some photographers were involved with imaginative images, such as elaborately fabricated pictures (from many negatives) by Oscar G. Rejlander (1813–75), and experimental photographic motion studies by Thomas Eakins (1844–1916) the painter, and Eadweard Muybridge. After French impressionism and other expressive styles of painting came along there was a move to unconventional camera and darkroom imagery, published and exhibited. Today soft-edged camera images are described as painterly, a complimentary reference to blends of colors or materials, overlapping exposures or surrealism. Contemporary computer-manipulated pictures and more dar-

When Pat R. Murphy showed me his enlarged print of multiple lightning flashes, I was amazed and asked to borrow it. He chose a wide viewpoint for his Nikon 8008 with 35mm lens on a tripod. He opened the lens on B for the first flash and left it open for several more that followed. From experience he set the aperture at f/6.3. Pat scanned the Ektachrome 200 slide into his computer to enlarge and print it. He says he's been hooked on photography since he bought his first 35mm camera at a yard sale.

ing camera-originated works still manage to escape the literal qualities expected from photography.

That said, to make attractive, sometimes painterly images, consider zooming your camera lens *during* an exposure at dusk or after dark. Night signs, displays, office building windows or Christmas decorations are typical targets for zoom exposures. Here are some guidelines:

- Zoom the lens from wide-angle to telephoto or the reverse. Keep notes and decide if you prefer the results of one technique over the other. Both can work well depending on the lens, on

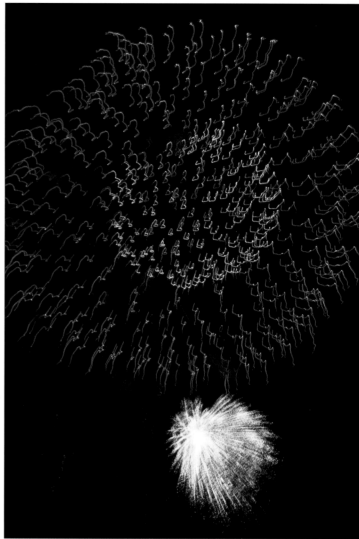

Left: At the Living Desert's brilliant Christmas light display in Palm Desert, CA, my SLR was on a tripod with a 28–80mm lens on it and Ektachrome 100VS in it. I shot a lot of the light displays with various exposures, and then made some zoom-during-exposure pictures. This was a five-second exposure between f/8 and f/11 on Ektachrome 100SW. Serendipity turned the light pattern into a visual surprise. **Right:** Two separate exposures resulted in big red and small yellow fireworks explosions on the same Kodachrome slide. I doubled the film's speed for correct exposure, and estimated where each image would be. Taken with an SLR and 28–135mm lens. More details in the text.

how fast you zoom, and on the type of subject.

- Handheld zoom exposures are usually satisfactorily sharp. If you don't hold the camera completely steady, its movement contributes to the lines of light created on film when a shutter is open for a zoom interval.

- Exposures between five and ten seconds from f/5.6 to f/8 make good zoom images using ISO 100 and 200-speed film. Short handheld exposures, such as two to three seconds, in many situations don't give you enough time to achieve the best zoom patterns. Experiment. Count seconds in your mind and keep a record of exposures. When using ISO 400 or 800 films, stop down from the above mentioned apertures. With my SLR on a tripod, I shot a large Christmas light display shaped like a vintage wood-burning locomotive (opposite page). The steady camera assured me of straight zoom lines that are not otherwise as predictable. There's exposure data in the caption.

- A majority of zoom-exposure subjects are not in motion, and the longer you expose, the slower you may zoom. Test several f-stops for zoom pictures at different intervals. If you want to slow down your film to zoom longer, use a 2X neutral density filter to reduce your ISO rating by half.

- With a point & shoot camera that offers only one- or two-second exposures, use ISO 200 or 400 film and experiment with zooming. If prints are muddy, they're underexposed. Switch to ISO 800 or 1600 film to find out what your camera will do. A two-second zoom can be done quickly with a motor-driven zoom lens.

Subjects with patterns or groups of dominant lights are most suitable for zoom exposures. With zoom pictures at night, expect the unexpected. Don't be timid about zooming because film is cheap compared to many worthy photo opportunities.

FIREWORKS

Waiting on the grass in a park on the Fourth of July, be patient and let the fireworks begin before shooting, to understand where in the sky to aim. Choose a zoom focal length setting that fills the finder to capture aerial bombs exploding in bright lines. Using ISO 100 or 200 film with an auto-exposure SLR, set a shutter speed at about ⅛, ¼ or ½ second. Typical fireworks reach a pretty peak at those exposures, but not all fireworks are created equal. The longer the shutter is open, the larger the explosion pattern. The camera will choose an aperture to suit the shutter speed and there's no concern about depth of field up there in the sky. First attempts at fireworks will test your educated guesses about framing pictures because you can't see what's happening on film with the SLR mirror up. Point & shoot or digital window finders give you the advantage of watching patterns of fireworks as you shoot. And of course you see immediately what you got on a digital viewing screen.

When two or three fireworks bursts brighten a dark sky at the same time, shoot as they

overlap. Or make two separate exposures on one frame of film with the multiple exposure setting. Double the film's ISO speed (or set exposure compensation for minus one stop) so two exposures add up to one correct exposure. Shoot one burst, remember where it was in the frame, and shoot another burst, hoping they relate or overlap. Some of my best fireworks shots were multiple exposures.

Another way to attempt a multiple exposure of fireworks is to mount the camera on a tripod, select a "T" (time) or "B" on the shutter speed dial, double the ISO number and set the lens for two explosions on the same frame. As a burst begins, depress the shutter button. Wait a second or two, then cover the lens with your hand, until there's another burst to fill the frame. Close the shutter. Pictorial success plus serendipity will teach you to guess exposure times and how to position the lens for overlapping bursts.

FIRELIGHT

A campfire is an easy subject to photograph at night. Set your camera on a tripod a comfortable distance from the heat. Use a zoom lens

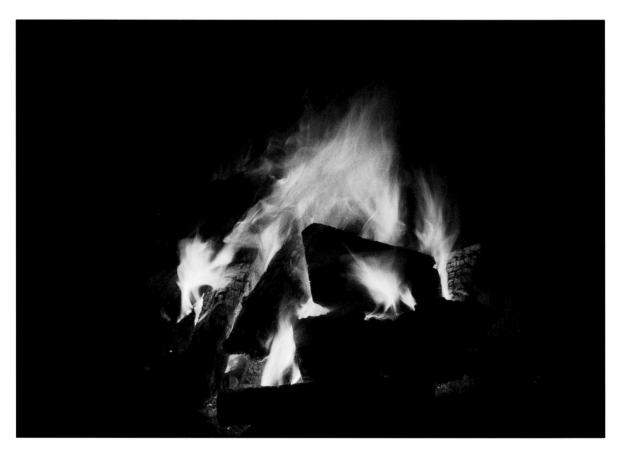

Photographing a campfire is like watching a miniature movie. The flames weave and wave, dark areas are there and gone, wisps of fire are animated. With an SLR on a tripod I shot this at $^{1}/_{15}$ second or $^{1}/_{8}$ second on Ektachrome 100VS. Campfire images vary according to the materials burning. Logs look different on fire than does scrap lumber.

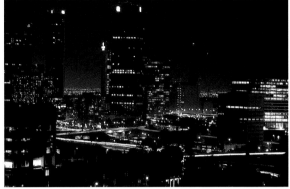

Left: Time exposures for Christmas decorations are related to those for photographing lit buildings at night. I had a grand time exploring this extraordinary display comprised of thousands of lights patiently placed by a small crew of people. Exposure on a tripod was one second or two seconds on Ektachrome 100VS in a single lens reflex. **Right:** Los Angeles a few years ago from a hill above the downtown area. The white streaks are headlights, the red ones, taillights. Greenish office windows indicate fluorescent lights. Taken with a now-outdated Konica SLR using a 50–150mm zoom and Kodachrome 64. Exposure was probably five seconds.

for convenience and frame the whole fire or a segment that suits you. Follow the automatic exposure indicated by the camera because bright fire with a dark background is viewed by the meter as close to 18 percent gray. Try a series of shutter speeds such as $\frac{1}{15}$, $\frac{1}{8}$ and $\frac{1}{4}$ second for a choice of blurred fire images. Longer exposures make the fire softer, so try $\frac{1}{30}$ second for sharper images. Logs or pieces of lumber in the fire are welcome dark contrasts.

PHOTO PROJECT

As I've been preaching, night photography is fun. If you live somewhere with good views of streets and buildings from a high spot, take your camera and tripod there at dusk and shoot the skyline or a pattern of streets at twilight with leftover daylight on the horizon, and after dark, too. For the experience, also shoot some city views while zooming the lens.

You'll be pleasantly surprised with what happens. On the other hand, if you're disappointed when you get the pictures, please go back and shoot again. Success is guaranteed!

If you live in a flat town, try shooting from a high building vantage point or a spot on the sidewalk of a main street. Compose buildings with signs and lit windows, etc., and take pictures as night falls and after. Shift camera viewpoints to a colorful sign or other subject, and also zoom the lens during exposure.

Ghost Images. After dark, set a camera that permits multiple exposures on a tripod opposite part of a lit motel, movie theater or restaurant. Check the exposure, then cut it in half. As an example, if the whole exposure is two seconds at f/8, shoot first at one second at f/8, with or without people in the shot. Be careful not to shift the camera. Then ask a friend to lean against a wall or pole in the picture, and shoot again at one second at f/8. Try it again with someone emerging from a door

in the second exposure. In your print or slide, the background will show through the ghostly model. Shoot variations by changing angles, model placement or location.

You can also do ghost images during the day indoors. By doubling the film's ISO, shoot half of a normal exposure of someone sitting in a chair. Don't move the camera. Then have the model stand beside the chair as if talking to him- or herself seated, and expose

again. You may be asked, "How did you do that?"

Get involved for an hour or two, and fill a roll of film (24 or 36 exposures). Your reward will be the challenge of practicing lighting arrangements. While this project may seem to be something of a struggle, it's worthwhile to learn how to solve basic lighting problems.

FOR INSPIRATION . . .

Roadside Project. The April 2001 issue of *Popular Photography*, a magazine I recommend, featured a story about Lucinda Lewis who did a book titled *Roadside America: The Automobile and the American Dream,* published by Harry N. Abrams, Inc. She included classic cars in various vintage roadside settings such as at a diner, a gas station and a wigwam motel. All the pictures in the story were shot at night or at dusk and dawn. I have not seen the book but Lewis used some esoteric lighting sources such as 1000W and 2000W tungsten floods powered by a portable generator for a period motel and at other locations. Perhaps you can find the book.

Painting with Light. There's a low-cost process called painting with light that comes in handy at night for subjects that are too spread out for an average floodlight or camera-mounted flash to cover. To paint with light, choose a building or subject where no tungsten lights will grossly overexpose during a long exposure. With an ISO 400 or faster film, place your camera on a tripod, shine a strong flashlight on the subjects or ask someone to walk beside the subject with a flashlight to help you frame and focus.

If your camera has it, set the shutter at "T" so it will stay open until you depress the button again, or use a remote release that locks. Based on a guide number, which in this example is 120, set the lens aperture at f/8, determined by dividing fifteen (feet) into 120. Open the shutter. With a portable flash unit and fresh batteries for minimum recycle time, you or your assistant should stay fifteen feet from the building, and move along to flash the whole length, height, etc. The person with the flash should stay out of camera range so his faint silhouette doesn't appear in the picture numerous times. Thus you paint, or illuminate, a building, one flash at a time. Done properly, there's little or no evidence of overlap. Frank Peele's masterful library interior, pictured in chapter 7, is an excellent example of this technique.

For more painting-with-light pictures, there's a story on ghost towns in the May 2001 *Smithsonian* magazine. Photographer Berthold Steinhilber evidently used a view camera and walked from one building to another in some scenes, flashing them and the foreground grass as well. The ghostliness of old mining towns in five western states is dramatic. Go to www.smithsonian-mag.com/journeys/ for details on how the photos were made and tips from the photographer.

CASE HISTORIES IN SUN AND SHADE

SOME ADDITIONAL IMAGES ARE PROVIDED IN THIS AND THE NEXT CHAPTER FOR YOUR INFORMATION AND INSPIRATION.

When first you see the pictures, please make a quick evaluation of the lighting before you read the captions. Do you feel that the quality of light seemed to dictate the camera angle or the composition? Determine which two shots utilize flash fill. If you came across similar picture situations, would you have taken the time and effort to make photographs?

Some images in this chapter required more time and travel than others. Where could you go to find special photo opportunities? Are you now more inclined to look for subjects that are photogenic because the light is right? What kind of light is most likely to motivate you? You don't have to know Charlton Heston or hire a beautiful model, because with imagination and resourcefulness you can find your own pictorial challenges. Get into a regular photographic habit, and make creating

The exterior of Lincoln Shrine in Redlands, CA, is by Frank Peele. The building houses the largest collection of Lincoln and Civil War materials west of the Mississippi. Frank's equally spectacular interior photograph appears in chapter 7. Frank exploited an exquisite light quality by making two exposures on Fuji Provia 100 film with a Mamiya RZ67 (medium format) camera. Exposure details below.

great images a delightful and important part of your life.

Frank's first exposure for the above image was made just after sunset to eliminate tree shadows that surround the building. A second exposure of four minutes on the same frame of film was made an hour later, after dark, to bring up artificial lights inside and outside the building. During the second exposure a car parked on the street within the scene, creating headlight streaks. In addition, the sky on the day of the shoot was devoid of clouds or color. To correct these flaws and reduce distracting background elements, Frank replaced the sky and eliminated evidence of the car using Adobe Photoshop. In addition to the Mamiya, he used two 35mm backup cameras because if there had been glitches, the double exposure would have been ruined and Frank would have had to start over another day. The final print was made from a scanned transparency.

Lydia scanned the slide of Chuck (facing page), imported it to her computer, and tweaked a few places using Photoshop 5. For many years she made conventional color prints in a well-equipped darkroom, but today she's an enthusiastic expert in the world of computer imagery.

Lydia Clarke Heston has a recognizable model in her husband Charlton who was working in a film titled "The Path of Moses" when this was taken in Timna Park, Israel. It was a warm day and as part of the film Chuck (his more familiar name) had been hiking with a group. Lydia posed him momentarily in this quietly dramatic side light while she shot some Ektachrome slides with a Canon EOS camera. "I've taken hundreds, maybe thousands of pictures of my husband," she says, "but there are often new lighting opportunities."

Left: Close-ups in daylight, sun or shade are a pleasure when you can move the subjects to various locations until you find lighting you like. I placed the small pot of cactus flowers in the sun on a piece of black fabric. It was noon in summer when the light came straight down and made almost no shadows. I shot on a tripod with an SLR, a 28–80mm Canon lens and Ektachrome 100VS film, which I like for its vivid, but not exaggerated, colors. The black background helps set off the flowers. **Top Right:** Most photographers are easily hooked on pattern subjects, and these polished red stones on display at a rock show in Quartzite, AZ, appealed to me. A well-lit pattern requires you to select a photogenic segment to shoot. Visualize a composition, then set the camera and refine your mental view through the finder. Shooting from a tripod assures sharp images and helps you make small camera adjustments easily. Shoot alternate compositions as well. I used Ektachrome, an SLR and a 28–80mm lens, which focuses closely at 80mm. **Bottom:** Murray Olderman is a professional sports cartoonist whose main hobby is photography, especially when traveling. When he and wife, Nancy, (photographed on a couch in chapter 7), toured parts of Europe, the Kremlin (a mass of government offices in Moscow) loomed up as a picture ready to be taken. "I walked along one side," he says, "shooting different views of the Oriental towers on Kodachrome with my Konica Autoreflex and a 50mm lens. The appeal of theatrical sculpture and decor attracted me." Murray scanned the slide to make a print to which he added a reddish tint, "as a kind of political comment," he adds.

Left: Ordinarily I dislike shooting in the rain because, even if protected, the camera may get wet. Also, rainy daylight offers little contrast, but subjects like this compensate with their own form and color. The ancient castle at Carcassone in France outwitted the light to maintain its curves, geometric planes and medieval mood. I used a rangefinder Contax camera, a 28mm lens and Kodachrome. **Top Right:** In contrast to the darker photo of the workman (bottom right) is a double portrait, also lit from the side with flash fill to brighten the subjects' faces. My son and his friend had just landed his plane and I framed them with portions of the colorful fuselage and tail. Atop my Canon Elan 7 camera was a Canon TTL (through-the-lens) flash unit that balances daylight and fill light in milliseconds. The lens was my favorite 28–135mm Canon zoom. Ektachrome 100VS slide film was used. **Bottom Right:** This strong portrait was part of a series on agriculture in California that photographer Maurice Manson shot for a 200-slide museum show. There's a hint of corn in the background, which the man was picking. Side lighting was ideal for the profile, taken with a medium-range zoom lens on an Olympus SLR.

Right: On assignment indoors I was shooting tungsten-balanced Ektachrome with 600W quartz units that were brighter than the ceiling fluorescents. At lunchtime, as the editor drove our rental car to a restaurant, I shot rainy street scenes through the windshield. The sun peeked out to add highlights to this one. I counted on the tungsten-type film to give the scene a bluish tint to symbolize the rain. In similar circumstances, or at twilight, experiment with tungsten slide film, or use an 80A blue filter with daylight slide or print film. Make a note to the processor to retain the blue tint.

When professional photographer Ken Whitmore shot pictures for the annual report of an international company, one location was a train station in Brussels, Belgium. "The design of the station was impressive," Ken says, "and I wanted to show it in an atypical way, so with my Nikon SLR on a tripod, I made a composition featuring strong directional elements. I knew passing trains exposed at half a second or longer would make attractive blurs, and I asked a colleague to stand where he would enhance the blur effect." Skylight illumination was all Ken needed.

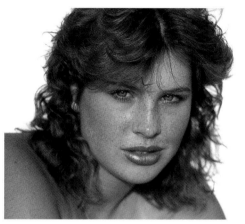

Top Left: The zoo in Memphis, TN, like so many zoos in the US and abroad, is a wonderland of animal subjects. But zoo situations can be difficult to photograph successfully because animals retreat into their lairs in hot weather or they hide in foliage or behind rocks. Even when the light on zoo animals is ideal, you may have to shoot through wire cages or plate glass, or the target is too far away for your lens. I was delighted to find a jaguar posing for me in bright shade within easy range of my Canon 75–300mm lens. The film was Ektachrome 100SW. **Bottom Left:** Sunlight, filtered through clouds to half-power, is soft illumination that lucky photographers make the most of for portraits. My model (a neighbor) was in front of an off-white wall at a swimming pool. She was comfortable, and I was delighted to achieve simple studio-type lighting outdoors. My SLR camera was handheld and I used Ektachrome 200. We both liked her sultry look. **Top Right:** Margaret LeBoutiller, retired from Boeing in Seattle, often visits her native England where she made this tranquil, softly-lit picture at Trinity College in Cambridge. She maneuvered with her Canon Rebel 2000 to catch the tower reflection amidst the roses. Margaret makes the most of a Tamron 28–200mm lens, and shoots both Fuji and Kodak negative films. Of her visit to Cambridge she says, "One could lose oneself in the history and architecture."

Right: Cheryl Himmelstein is a remarkable natural light photographer who made an elegant portrait of attorney Melanie Lomax in a conference room of her office. Cheryl used only bright incoming light and when she printed the 4x5 negative (Fuji 160 NPS exposed in a Toyo field camera), she adjusted the balance of indoor and outdoor lighting. Civil rights specialist Melanie Lomax is a former Los Angeles Police Commission President, and her photo was shot for a *Los Angeles Times* magazine story. **Bottom:** Kristal Snowman is a flight attendant who enjoys photography wherever she goes. She and her husband, Cliff, were sightseeing the sunset at Drakes Beach in Pt. Reyes, CA, and both carried their 35mm SLR cameras and Bogen tripods. In one direction, Kristal says, there were no good shots, but when she turned around, "I saw this incredible effect of the pale sun on the cliff and the gorgeous water pattern. The sun was just low enough to have a wonderful alpenglow appearance." The image has the fine qualities of a landscape painting. Kristal used a Nikon F3 with Nikon 80–200mm zoom and Fuji Velvia slide film.

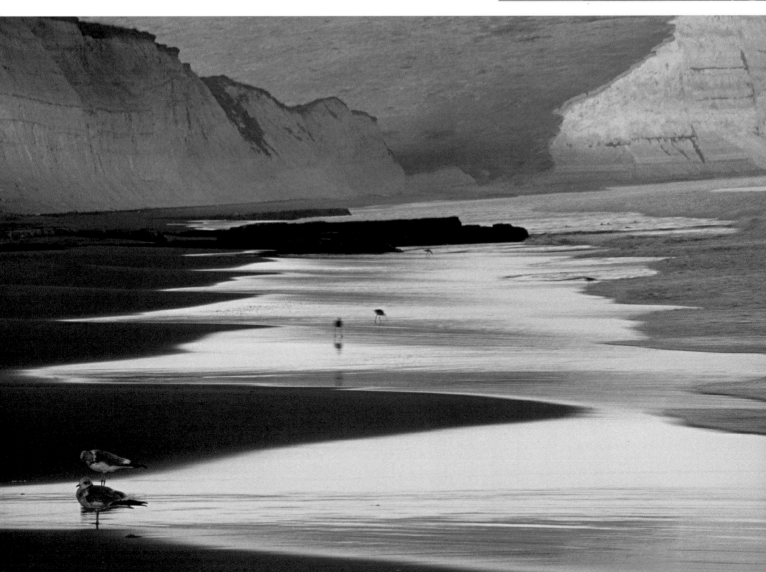

CASE HISTORIES INDOORS AND AT NIGHT

THIS FINAL CHAPTER FEATURES

A SMORGASBORD OF PHOTOS TAKEN WITH TUNGSTEN LIGHT, FLASH AND AVAILABLE DAYLIGHT.

Most locations will be familiar to you, but some techniques may be new, such as intentional blur and zoom light patterns. If a picture appeals to you, try to find or create a parallel situation for yourself. If you don't own adequate lighting equipment, the material in this chapter and in chapter 7 will help you determine what you need. Be aware of your motives before you add equipment. New gear is appealing, but it's useless until you convert your investment into first-rate pictures.

Creative photography is fun, but it's also work. Luckily, using your imagination, being resourceful about lighting equipment and using it, or getting out there to shoot isn't hard work when you are motivated. Look at pictures in magazines, books and exhibitions. Shoot around home, and at home. Go on the road. You can't mount and frame excuses.

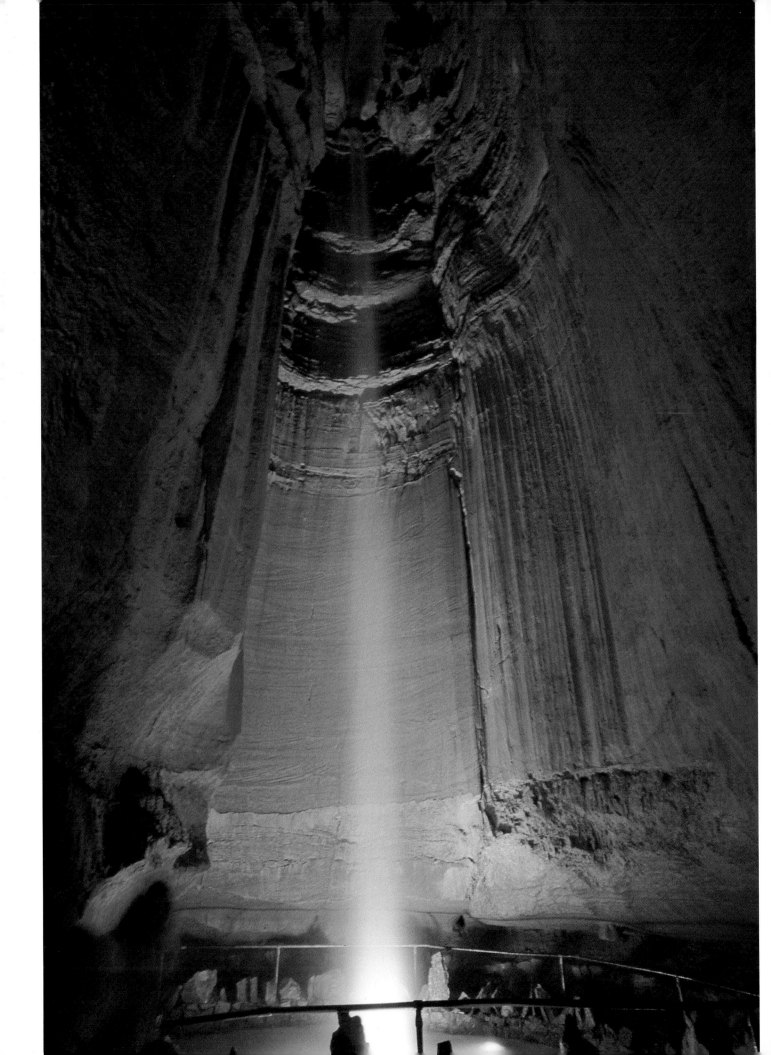

Opposite: Eleven hundred and twenty feet below Lookout Mountain Scenic Highway at the edge of Chattanooga, TN, is a remarkable cavern where unique Ruby Falls drops 145 feet into a dramatically lit pool. Settings like this require a tripod to get sharp pictures on most films slower than ISO 1600 or 3200. My SLR was loaded with 100VS Ektachrome and the camera-indicated exposure was one second at f/8 with a 28mm lens. The falls became a continuous ethereal blur. I watched other visitors shooting with flash in their cameras, which inevitably resulted in disappointing underexposure, even with very fast film. Carrying a tripod isn't a chore because access to the falls is by elevator. I was reminded of touring Carlsbad Caverns in New Mexico, where three-to-five-second exposures were common on ISO 100 film, but the pictures were worth walking a few underground miles. At Carlsbad take a 21mm lens if possible. **Above:** When I travel, I like exploring for pictures on foot during the day and into the evening, so at the harbor in Gothenburg, Sweden, I was rewarded by lovely light. The rowboat with wisps of setting sun on it was tied up under a narrow pier. In the background was the fortunate reflection of a red boat hull. I set exposure compensation in my Canon Élan SLR to underexpose by one stop and a half a stop. If that sounds odd in dim light circumstances, remember that the camera meter tries to average a scene into 18 percent gray, which would have brightened the dark tones and overexposed the slide. Because overexposed color negatives print just fine, the meter setting would probably have been okay.

Top: Daylight flooded through full-length windows off camera at the left in a large and ornate room at the palatial home of the Duke of Devonshire in England. Many such tourist attractions, including museums, prohibit using tripods because photographers tend to hold up tours, or because someone might trip over a tripod leg. In some locations you can brace yourself against a wall or a pillar, holding your elbows against your chest with minimum tension. I backed into a wall here, and with Kodachrome 64 in my SLR and a 28mm lens, I exposed at about $1/10$ second at f/8. Luckily the image is sharp. **Left:** Indoors, flash is always available. In a small bath-

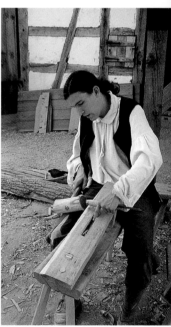

room I bounced my separate flash against the ceiling where it was also picked up by wall mirrors and reflected onto the child in the sink. The flash was a Vivitar 283, which computes exposure via a sensor that quenches the light when there's enough. I used an SLR and Ektachrome. Never underestimate the visual power of reflected light. **Right:** It's hard to resist ideal indoor daylight situations when the subject is worthwhile. Eventually, we learn to turn away when a subject just isn't pictorial. If I shoot anyway, my weak alibi to myself is usually, "because it was there." In this case a young man in period costume, crafting a "shaving horse" at the Museum of the American Frontier Culture in Staunton, VA, was worthy of the pleasantly diffused lighting. With a 28–105mm lens on an SLR, I composed to show what he was doing. The film was Ektachrome 100SW, though almost all slide and print films would have done a good job here.

Taken by Tammy Loya, an outstanding professional from Ballston Spa, NY, who specializes in photographing children. Tammy works in a studio she designed using Photogenic 1500 studio flash units, a 4x6-foot softbox, a five-foot Balcar umbrella and other equipment. However, this lovely portrait was illuminated by a 6x6-foot north-facing window. She cajoles her young subjects into relaxing for her Mamiya RZ or Canon A-2 camera. A large reflector on a rolling stand off to the right produced fill light to soften shadows. Tammy shoots negative color such as Kodak Portra 400VC, and sells prints as large as 24x30 inches from 6x7 negatives.

Top: These baby mourning doves are only two weeks old. Their parents built a rickety nest in vines beside our home, and mama sat on two eggs for about three weeks. With a short ladder I was able to shoot about fifteen inches from the fast-growing babies with a 50mm macro lens on a Canon Elan II. The film was Kodak Ektachrome 100VS, though many slide and print films could have been used. Each flash was so brief, the birds didn't seem to mind. Since most small birds build nests in sheltered spots, it's necessary to shoot with flash. Some zoom lenses focus closely enough to photograph small subjects. If you need them, investigate add-on close-up lenses. **Left:** It's not a strawberry with a wig. It's a spotted anemone (generic name, telia loftensis) photographed in a tank at the Newport, Oregon aquarium. This specimen of sea life, about eight inches long, was illuminated from above by tungsten lights. I braced my hands with my SLR against the glass to expose, as I recall, at $^1/_4$ second at f/6.3 on Ektachrome 100SW. The lens was a 50mm Sigma macro that will focus 1:1, which means life size on film. I was surprised to find how well the color looked on daylight film

without a correction filter. **Right:** To add visual punch to an annual report, specialist Ken Whitmore used colored filters over his strobes to glamorize a Texas industrial laboratory. The technician testing airplane instruments was photographed on Ektachrome with a Nikon SLR and 24mm lens on a tripod. Ken used red and magenta filters over a monolight on the background and over two other strobes, one high on the left and another low on the right. Photo supply stores or those selling stage lighting equipment may stock colored gels for experiments you could try. **Opposite:** Every few years I have an opportunity to photograph the Golden Gate Bridge, usually from a Marin Highlands vantage point, and more recently from a light plane. But this late dusk view is one-of-a-kind in my files. At first I felt it had too little tonal contrast, but I see it now looming like a huge structural ghost. I shot with Kodachrome 200, but I don't recall the exposure, which was probably $^1/_2$ second because the headlights are only slightly blurred.

Above: I got permission to shoot—without flash—a small dance company rehearsing at a local theater. Though this image was taken from a tripod, it may not seem so. The stage lighting was suitable for the dancers, but not bright enough for me to get sharp slides on Ektachrome 100 with a now obsolete Konica SLR and a 50mm lens. Intentional blur can be achieved at shutter speeds such as one second or half a second, depending on how fast the subject moves. This was taken at $^1/_2$ second. At a faster speed there is less blur, and slower than one second, individual dancers almost disappear. **Opposite:** As the finale for this book I picked a zoom-during-exposure slide taken at an amusement park light show. Little bumps interrupting the streaks indicate where I hesitated very briefly during the zoom process with a handheld 28–135mm lens on a Canon SLR. No two zoom-exposure images are alike, even if you shoot from a tripod, because zooming varies each time. Try zooming lights for an adventure in image-making.

GLOSSARY

Accent light—A light, from one side or another, or from above, used to add a bright accent to hair and other subjects.

Aperture—Another term for lens opening or f-stop.

Bounce—To aim a light source (such as flash) at a reflecting surface, such as a ceiling or wall.

Bracket—To make a series of exposures that differ from the metered exposure ($\frac{1}{2}$-stop or one stop more, and $\frac{1}{2}$ or one stop less, for example) to ensure a suitable exposure.

Color balance—A proper match of Kelvin temperature between film and light source so color is neither too warm nor too cool.

Contrast—The difference in tonal value between tones in black & white, or color tones. A high contrast photograph is made of predominately bright or light-colored tones. A low contrast photograph is comprised of predominately dark color tones.

Depth of field—The areas in front of and behind the focused distance that are acceptably sharp in a photograph. Depth of field is determined by focus distance and lens aperture. Depth of field is increased by closing the lens aperture, such as from f/8 to f/11.

Exposure compensation—To vary exposure for excessively bright (give extra exposure) or dark subjects (give less exposure) that a meter interprets as 18 percent gray. Many SLR cameras include adjustments for exposure compensation.

Finder—A window-like viewing device on a camera designed to show the subject area that will be recorded on the film.

Flash fill—Use of flash to brighten shadow areas in a photograph. Reflectors may be used for the same purpose.

Flash meter—A meter that measures the brightness of flash and indicates the f-stop for

correct exposure at the selected film speed. The meter may also measure ambient light.

Flat light—Even lighting with little or no contrast. Flat light from a softbox may be beautiful, while flat light from flash on camera may be uninteresting.

Gray card—A gray card that reflects 18 percent of the light falling on it, used to set exposures or evaluate exposure meter readings.

Hot light—Nickname for floodlights and quartz lights that become very hot in use.

Incident light—The light that falls on a subject from any source, as opposed to reflected light, which is light reflected by the subject. An incident light meter is designed to measure light falling on it, rather than reflected light.

ISO—An international standard to rate film sensitivity, or speed. A higher ISO number indicates a faster film, and a lower number indicates slower film.

Medium format film—A film size larger than 35mm and smaller than 4x5, such as 6x6 or 6x7. Used in medium format cameras.

Pixel—A unit of measurement to describe digital camera image detail. The higher the pixel number, in general, the sharper the enlarged images should be.

Point & shoot camera—Also known as a compact camera, this type usually has a non-removable zoom lens.

Recycle—That which a flash unit does between flashes when its power is replenished for the next flash.

Slave eye—An electronic sensor that, when plugged or built into an electronic flash unit, activates that unit when another flash is fired.

SLR camera—Designation for single lens reflex camera that uses a prism for viewing through the lens.

Softbox—A reflecting unit, usually lined in white with translucent cover, used to diffuse electronic flash lighting.

Strobe—A vintage name for electronic flash. The word comes from "stroboscopic light," a term used early on to refer to high speed light.

Umbrella—An umbrella-shaped reflector used to soften hot light sources or flash.

Zoom exposure—The process of zooming a lens during an exposure of one second or longer to produce irregular light streak patterns at night.

RESOURCES

Note: Many companies have multiple web sites and e-mail addresses for several departments. Single web and e-mail addresses are listed to get you started.

FLASH UNITS, HOT LIGHTS AND ACCESSORIES

Note: Many companies make or sell dedicated units for specific camera brands.

BKA
(Brandes-Kalt-Aetna Group)
Studio flash and monopack systems.
701 Corporate Woods Pkwy.
Vernon Hills, IL 60061
847-821-0450
www.bkaphoto.com

Bogen Photo Corp.
Numerous tripods and Metz electronic flash equipment.
565 East Crescent Ave.
Ramsey, NJ 07446
201-818-9177
www.bogenphoto.com

Denny Mfg. Co.
Photographic backgrounds, copious catalog.
P.O. Box 7200
Mobile, AL 36670
800-844-5616
www.dennymfg.com

Dyna-lite Flash Equipment
Studio flash units.
1050 Commerce Ave.
Union, NJ 07083
800-722-6638 or
800-844-5616
http://www.dynalite.com

Elinchrom
Studio electronic flash and lighting accessories.
Bogen Photo Corp.
565 East Crescent Ave.
Ramsay, NJ 07446-0506
201-818-9500
www.bogenphoto.com

Lowell Light Mfg. Inc.
Hot lights and accessories in catalog.
140 58th St.
Brooklyn, NY 11220
800-344-3426

Mamiya America Corp.
Profoto studio and location battery flash units. Also sells PocketWizard digital wireless slave.
8 Westchester Plaza
Elmsford, NY 10523
877-310-7700
e-mail: info@profoto-usa.com
www.mamiya.com

Nikon Inc.
Numerous sophisticated camera-top flash units.
1300 Walt Whitman Road
Melville, NY 11747
800-645-6687 or
516-547-8518
www.nikonusa.com

Norman Division of Photo Control Corp.
Studio flash units.
4800 Quebec Avenue North
Minneapolis, MN 55428
763-537-3601
www.photo-control.com

Photogenic
Professional studio lighting units.
525 McClug Road
Youngstown, OH 44512
800-682-7668
www.photogenicpro.com

Photoflex
Electronic flash and studio lighting accessories, handsome catalog.
97 Hangar Way
Watsonville, CA 95076
800-486-2674
www.photoflex.com

Quantum
Portable flash and battery packs.
1075 Stewart Avenue
Garden City, NY 11530
516-222-6000
www.qtm.com

Sigma Corp. of America
Portable electronic flash units and cameras.
15 Fleetwood Court
Ronkonkoma, NY 11779
www.sigmaphoto.com

Sinar Bron
Studio flash units.
17 Progress St.
Edison, NJ 08820
800-456-0203
www.sinarbron.com

Speedotron
Studio electronic flash.
310 S. Racine Ave.
Chicago, IL 60607
www.Speedotron.com

Sunpak/ToCad America, Inc.
Many models of portable flash units available.
300 Webro Road
Parsippany, NJ 07054
973-428-9800
www.tocad.com/new2.htm

Vivitar
Numerous portable flash units. Online catalog at http://vivitar.com/Products/pages/APS
Vivitar Central Parts & Service
1280 Rancho Conejo Blvd.
Newbury Park, CA 91320
805-498-7008
e-mail: cs1@vivitar.com

White Lightning
Economical studio flash units, remote wireless, stands, etc.
2725 Bransford Ave.
Nashville, TN 37204
800-443-5542
www.white-lightning.com

TRIPODS, BALL HEADS, FILTERS, AND FLASH METERS

Bogen Photo Corp.
Numerous tripods and Metz electronic flash equipment.
565 East Crescent Ave.
Ramsay, NY 07446-0506
201-818-9500
www.bogenphoto.com

The Saunders Group Division of Tiffen Co.
Polaris flash meter.
21 Jet View Dr.
Rochester, NY 14624
716-328-7800
www.saundersphoto.com/html/info.htm

Schneider Corp. of America
Black & white color correction filters. Offers 52-page filter guide.
Schneider Optics, Inc.
400 Crossways Park Dr.
Woodbury, NY 11797
516-496-8500

Sekonic
Division of Mamiya America Corp.
Flash meter.
8 Westchester Plaza
Elmsford, NY 10523
914-347-3300
www.mamiya.com

Slik
Division of Tocad America, Inc.
Tripods, distributors of Sunpak electronic flash.
300 Webro Road
Parsippany, NJ 07054
973-428-9800
www.tocad.com

Tiffen Manufacturing Corp.
Filters.
90 Oser Ave.
Hauppauge, NY 11788
800-645-2522 or
516-273-2500
www.2filter.com
e-mail: info@sekonic.com

FILM COMPANIES

AgfaCorp.
2605 Fernbrook Lane
Plymouth, MN 55447
800-866-0142
Professional Division:
www.agfahome.com

Eastman Kodak Co.
343 State St.
Rochester, NY 14650
Kodak Information Center:
800-242-2424
Professional information:
www.kodak.com/go/professional

Fujifilm
555 Traxton Rd.
Elmsford, NY 10523
800-755-3854 is a technical hotline; for professional information, ext. 73
www.fujifilm.com

SERVICES

Adobe Photoshop
Sophisticated image management programs.
800-833-6687 or 408-536-6000
www.adobe.com

MAGAZINES

American Photo
Classy consumer magazine.
1633 Broadway
New York 10019
212-767-6531

Outdoor Photographer
Quality articles and photos.
Subscriptions:
P.O. Box 57213
Boulder, CO 80321-7213
310-820-1500

PDN—Photo District News
Leading professional monthly magazine.
1515 Broadway
New York, NY 10036
212-536-5222
Circulation: 212-536-6422
www.pdnonline.com

Popular Photography
Leading consumer photo
magazine.
1633 Broadway
New York, NY 10019
Subscriptions: 850-682-7654
e-mail: popeditor@aol.com

Rangefinder
Monthly for professional
photographers.
P.O. Box 1703
Santa Monica, CA 90406
310-451-8506

Shutterbug Magazine
Tabloid-size with articles and
unusual ads.
5211 S. Washington Ave.
Titusville, FL 32780
407-269-3212
www.Shutterbug.net

Studio Photography & Design
Monthly for professional
photographers.
PO Box 47
Ft. Anderson, WI 53538-0047
Subscriptions: 631-845-2700

WEB SITES (AN INCOMPLETE
SELECTION)

A History of Photography
www.rleggat.com
Compiled by a British scholar,
this site posts new additions
monthly.

Ernst Haas Studio
www.ernst-haas.com
Beautiful work by a really fine
photographer (1921–86).

**North America Nature
Photography Association**
www.nanpa.org
A wide range of information—
from travel and photo gear to
professional tips.

Photobetty
www.photobetty.com
Celebrates female photo-
journalists, fine art, digital and
documentary photographers

Photo.net
www.photo.net
A kind of online camera club
started in 1993 featuring non-
stop talk from around the
world.

Photo Sharing Site
www.worldisround.com
Features travel and photogra-
phy, free-of-charge information
with links to other travel and
landscape web sites.

INDEX

Other Books from
Amherst Media

Portrait Photographer's Handbook

Bill Hurter

Bill Hurter has compiled a step-by-step guide to portraiture that easily leads the reader through all phases of portrait photography. This book will be an asset to experienced photographers and beginners alike. $29.95 list, 8½x11, 128p, full color, 60 photos, order no. 1708

The Art of Color Infrared Photography

Steven H. Begleiter

Color infrared photography will open the doors to an entirely new and exciting photographic world. This exhaustive book shows readers how to previsualize the scene and get the results they want. $29.95 list, 8½x11, 128p, 80 full-color photos, order no. 1728.

Posing and Lighting Techniques for Studio Photographers

J.J. Allen

Master the skills you need to create beautiful lighting for portraits of any subject. Posing techniques for flattering, classic images help turn every portrait into a work of art. $29.95 list, 8½x11, 120p, 125 full-color photos, order no. 1697.

Creating World-Class Photography

Ernst Wildi

Learn how any photographer can create technically flawless photos. Features techniques for eliminating technical flaws in all types of photos—from portraits to landscapes. Includes the Zone System, digital imaging, and much more. $29.95 list, 8½x11, 128p, 120 color photos, index, order no. 1718.

Basic 35mm Photo Guide, 5th Edition

Craig Alesse

Great for beginning photographers! Designed to teach 35mm basics step-by-step—completely illustrated. Features the latest cameras. Includes: 35mm automatic, semi-automatic cameras, camera handling, *f*-stops, shutter speeds, and more! $12.95 list, 9x8, 112p, 178 photos, order no. 1051.

More Photo Books Are Available

Contact us for a FREE catalog:

AMHERST MEDIA
PO BOX 586
AMHERST, NY 14226 USA

www.AmherstMedia.com

Ordering & Sales Information:

INDIVIDUALS: If possible, purchase books from an Amherst Media retailer. Write to us for the dealer nearest you. To order direct, send a check or money order with a note listing the books you want and your shipping address. Freight charges for first book are $4.00 (delivery to US), $7.00 (delivery to Canada/Mexico) and $9.00 (all others). Add $1.00 for each additional book. Visa and MasterCard accepted. New York state residents add 8% sales tax.

DEALERS, DISTRIBUTORS & COLLEGES: Write, call or fax to place orders. For price information, contact Amherst Media or an Amherst Media sales representative. Net 30 days.

1(800)622-3278 or (716)874-4450
FAX: (716)874-4508

All prices, publication dates, and specifications are subject to change without notice.
Prices are in U.S. dollars. Payment in U.S. funds only.

Traditional Photographic Effects with Adobe® Photoshop®

Michelle Perkins and Paul Grant

Use Photoshop to enhance your photos with handcoloring, vignettes, soft focus and much more. Every technique contains step-by-step instructions for easy learning. $29.95 list, 8½x11, 128p, 150 photos, order no. 1721.

Master Posing Guide for Portrait Photographers

J. D. Wacker

Learn the techniques you need to pose single portrait subjects, couples and groups for studio or location portraits. Includes techniques for photographing weddings, teams, children, special events and much more. $29.95 list, 8½x11, 128p, 80 photos, order no. 1722.